IMAGES of America
CICERO REVISITED

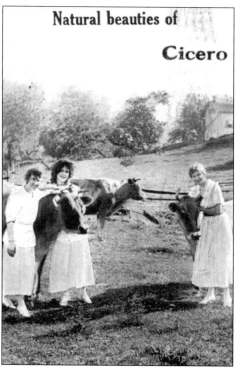

Picture postcards were the e-mail of the early 20th century. "Penny postals" cost only a cent to mail. Although it is doubtful this image was actually shot in Cicero, the picture represents the trend of emphasizing a romantic, pastoral image of suburbia. Mailed from Lottie to her friend Mae in 1919, the correspondent said she was now working "second shift" at an unnamed plant, "not milking cows—ha-ha!"

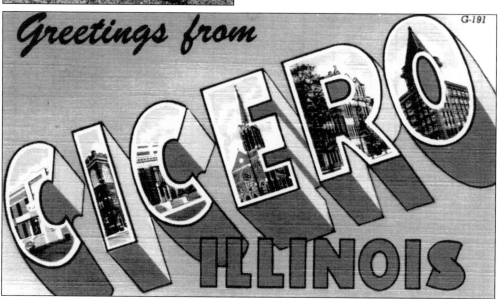

Hugely popular during the 1940s, large-letter postcards featured small scenic views within oversized capital letters that spelled the names of geographic locations. Here the first C features town hall, *I* is Redeemer Lutheran Church, the second C is the post office, *E* is St. Mary's of Czestochowa, *R* is Morton High School, and *O* is the Western Electric plant.

On the cover: These young Polish families, recent newcomers to the Hawthorne district, are typical of the Eastern Europeans flooding Cicero at the dawn of the 20th century. The house, much altered and adapted, still stands at 2915 Forty-ninth Avenue. (Courtesy of Rosemary Pietrzak.)

IMAGES of America
CICERO REVISITED

Douglas Deuchler

ARCADIA
PUBLISHING

Copyright © 2006 by Douglas Deuchler
ISBN 978-0-7385-4107-5

Published by Arcadia Publishing
Charleston, South Carolina

Printed in the United States of America

Library of Congress Catalog Card Number: 2006929432

For all general information contact Arcadia Publishing at:
Telephone 843-853-2070
Fax 843-853-0044
E-mail sales@arcadiapublishing.com
For customer service and orders:
Toll-Free 1-888-313-2665

Visit us on the Internet at www.arcadiapublishing.com

Cicero is named for a Roman orator and philosopher (106 B.C.–43 B.C.). His remark, "Ask not what your country can do for you, but rather what you can do for your country," is often attributed to John F. Kennedy. Cicero was hunted down and decapitated by his political enemies who then displayed his head in the Roman Forum.

Contents

Acknowledgements 6

Introduction 7

1. In the Beginning 9

2. The Early 20th Century 21

3. From Roaring Twenties to Wartime Forties 51

4. The Challenge of Change 93

5. Focus On the Future 115

ACKNOWLEDGMENTS

This book would not have been possible without the support and assistance of so many wonderful Ciceronians, past and present. I especially appreciate the use of rare Cicero memorabilia and vintage postcards belonging to two generous collectors, Frank Magallon and Charles Sterba. I am grateful to photographer Antonio Perez for his loan of some fine contemporary images. I am also deeply indebted to scores of folks who went out of their way to provide me with photographs, memories, scrapbooks, advice, and moral support, including Jose Alanis, Judy Baar Topinka, Dennis Bobbe, Theresa Brazda, John Bruen, Val Camilletti, Bea Cerny, Larry Dominick, Josephine Gadzinski, Esmeraldo Garcia, Dr. Hector Garcia, Diane Gneda, Carol Gore, Colleen Harris, Gladys Harris, Dr. Marilyn Hetzel, Ray Julius, Mary Hapac Karasek, John Kociolko, Charmane Kusper, Rosalind Larson, Juanita LoGuidice, Mildred Lipinski, Stacza Lipinski, Stanley Loula, Joe May, Gary Petzke, Rosemary Pietrzak, Don Racan, Dennis Raleigh, Jean Reehor, Robert Rektorski, Mary Esther Rodriguez, Vivian Rogala, Annette Schabowski, Richard Sklenar, Frank Skorski, Millie Slezak, Terry Spencer, and Ed Vincent. Thanks, too, to the reference librarians of the Cicero Public Library and the staff at the Theatre Historical Society of America.

I dedicate this book to my wife Nancy who is always supportive of yet another adventure, even if it means she will not see our dining room table for the next three months.

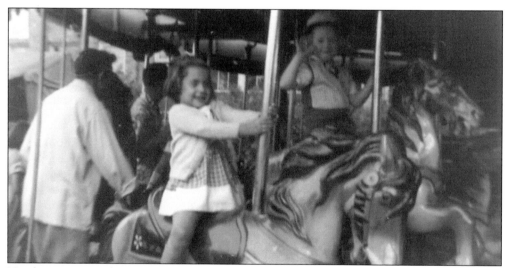

Nearly everyone who grew up in Cicero remembers the experience fondly. In this 1953 photograph, cousins Terry and Juanita Spirek are enjoying the merry-go-round at a St. Frances of Rome Church carnival, located at 1410 Austin Boulevard.

INTRODUCTION

From its earliest days, the town was clearly a unique place. Of course, there was never anything pretentious or trendy about Cicero, Illinois. Its working-class residents tended to plant themselves and their growing families, often staying for generations. No other Chicago suburb was as heavily Roman Catholic or as solidly populated with immigrants. With a strong emphasis on manufacturing, it was easy for adjacent, more affluent communities to look down their noses at Cicero.

Primarily as a result of the simultaneous arrival of so many different European ethnic groups, the town developed as a patchwork quilt of distinct districts. Cicero is made up of eight zones, each with its own identity: Boulevard Manor, Clyde, Drexel, Grant Works, Hawthorne, Morton Park, Parkholme, and Warren Park. These separate neighborhoods began as virtual villages—self-contained ethnic enclaves—with their own churches and business districts. A narrow wooden sidewalk led across the prairie from "town" to "town." Before widespread automobile ownership, residents in these autonomous sections were largely confined to interacting with one another.

Although the community was chock full of foreign-born residents, Cicero was never a melting pot of ethnic integration. A lifelong Cicero senior recently recalled, "A 'mixed couple' when I was coming up was when a Polish girl from Hawthorne might be dating an Italian boy from Grant Works. Yes, they were both Catholic. But they came from different worlds. There'd be hell to pay for the both of them. That's just the way it was."

Located seven miles from downtown Chicago, Cicero is the suburb closest to the Loop. It remains a major manufacturing center in Illinois, as well as one of the oldest and largest municipalities in the state. With its population estimated at over 100,000, Cicero celebrates its 150th anniversary in 2007.

Yet the town has often suffered from an image problem. Its hard-working, frugal, family-oriented residents have long struggled to live down its reputation as a criminal, race-hating town. The media has routinely taken cheap shots at the strongly industrial-based community, portraying Ciceronians as backward, prejudiced, and corrupt.

This pictorial history attempts to illustrate the life and times of Cicero without sidestepping some unpleasant aspects of the saga. An accurate documentation of the past can illuminate the future. Yet the focus will be to salute and celebrate the town as a true survivor deserving our respect and recognition.

It is impossible for one slim volume of 128 pages to capture the panoramic history of such a multifaceted community. No matter how painstakingly the images are selected, not every church, school, industry, business, or organization can be included. Yet it is hoped that the 230 photographs and accompanying text will provide a sentimental journey, a fun bit of "time travel," which will allow the reader to experience the thrilling growth and development of Cicero from its first settlement down to its exciting new directions.

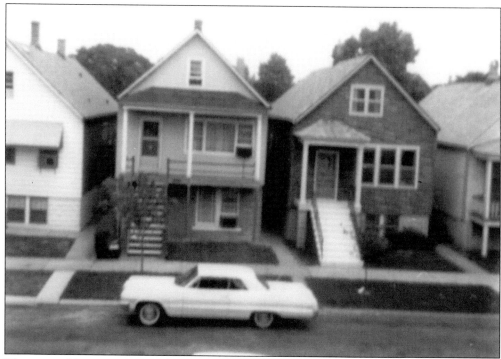

The town of Cicero sports a wide range of 19th- and 20th-century residential architecture. Here the north side of the 5000 block of Thirty-second Place in the Hawthorne district in 1966 is seen. Most of the homes in this section are frame "workers' cottages" from the 1880 period. From the start, Cicero was a community of strong neighborhoods.

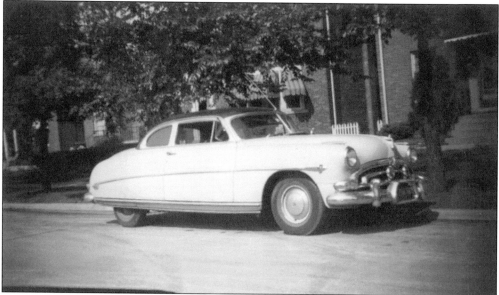

This 1952 Hudson is parked in front of 3331 Sixty-first Court in Boulevard Manor, a neighborhood developed after World War II. Because so many veterans were simultaneously buying homes in that section, it was often called Mortgage Manor. Previously this district had been several large vegetable farms.

One

IN THE BEGINNING

The indigenous people who lived in what would become Cicero Township settled in the vicinity as the Ice Age glaciers retreated. They hunted deer and waterfowl, gathered seeds and berries, planted squash and maize (corn), and eventually traded muskrat, beaver, and raccoon pelts with the French. After the Blackhawk War of 1832, when the Potawotami tribe was forced to retreat west of the Mississippi River, the land was opened up for white settlement.

In pioneer times, the region was part of the great Northwest Territory. The earliest settlers built cabins along a former Native American trail that ran diagonally from Lake Michigan out into the hinterland. William B. Ogden (1805–1877), the first mayor of Chicago (who married for the first time at the age of 70), had this route paved with eight-foot-wide wooden planks to create a solid surface across the muddiest stretches of the area. The resulting thoroughfare was eventually called Ogden Avenue in his honor.

On June 13, 1857, 14 settlers met to organize a local government for their new district, which they named "the Town of Cicero." During the first year of its existence, the entire tax levy was $500, the bulk of which was spent on road repairs and drainage ditches.

Cicero was initially an enormous 36-square-mile tract that dwarfed the city of Chicago in size. This massive township was bounded by what are today Western, North, and Harlem Avenues, and Pershing Road. (Western Avenue was so named because then it was actually the western border of Chicago.)

The community grew slowly until after the Civil War when the cheap farmland began to attract more homesteaders from the east. During the 1860s, Cicero grew from a handful of farming families to a community of 3,000 people. The marshy "Mud Lake" wetland, with its various tiny ponds and channels, began to recede with the construction of the Illinois and Michigan Canal. This swampy lowland was further drained by a network of some 50 miles of ditches. Yet early Cicero remained mired in mud for decades.

A number of displaced Chicagoans, burned out by the Great Fire of 1871, became Cicero's first significant population boom. Large numbers of other newcomers, many of them recent immigrants, were hired at either the stone quarry in the Hawthorne district or the factories springing up in the northeast sector of town adjacent to the new railroad lines. Thus the town grew from east to west.

By the late 19th century, Cicero had become an industrial hub. Large families now swelled the population, occupying cozy cottages and establishing churches where they could worship in their own languages in their own neighborhoods. There were no sidewalks or paved roads. Most people traveled on foot to their destinations, so each "village" had its own business district.

Father Jacques Marquette (1637–1675) was a French Jesuit priest motivated to tour the wilderness to "convert the savages." He and Louis Joliet (1645–1700), a Canadian explorer, became the first non-natives to pass through the marshy, mosquito-infested region that would become Cicero Township.

After Marquette and Joliet opened up the region, French fur traders swarmed in, bartering for pelts with the indigenous tribes. Unlike the English settlers, who came later, the French got along well with the Native Americans and often married into the tribes. The Potawotamies were forced to retreat west of the Mississippi River in the 1830s.

The diagonal American Indian trail running from the lakefront out into the hinterland became one of the early thoroughfares through south Cicero. As traffic grew heavier, Cicero appropriated funds to lay a Plank Road. But this was a dangerous route as animals that stumbled between the logs could suffer broken legs and would have to be destroyed. In the 1920s, the paved highway, now called Ogden Avenue, would become a section of Route 66.

This stagecoach is about to leave Chicago. Its first stop will be on Ogden Avenue in frontier Cicero Township. Such stagecoaches were often overloaded with passengers. The "shotgun rider" sat next to the driver on top to protect everyone from bandits in the hinterland (their crime was known as highway robbery).

The first pioneer families settled along Ogden Avenue, the diagonal former American Indian trail. Following the removal of the indigenous people from the region in the 1830s, the territory was opened up to anyone wishing to establish a small farm. But since much of the land was so marshy, settlement by homesteaders was slow at first. By the 1850s, only 10 families lived in the swampy lowlands that are now south Cicero.

After great delay, the Illinois and Michigan Canal was constructed between 1845 and 1848. This hard, dangerous task was accomplished by mostly Irish immigrant laborers who worked for $1 a day, six days a week. The 60-foot-wide, six-foot-deep canal, which connected the Great Lakes to the Mississippi River, opened up the West and raised the status of the entire Chicago region. In the mid-20th century, the Stevenson Expressway (I-55) was built over much of the original 97-mile canal route.

Austin Avenue and 12th Street in 1860

The work of clearing and draining the land was hard and tedious. Most of the earliest settlers in Cicero Township were farmers, either tending dairy cattle or growing hay. There was great demand for the latter in the horse-drawn world of the 19th century.

After the Civil War, Cicero land was selling for $10 an acre. Wealthy entrepreneurs from the East swooped in and began to develop subdivisions. The Clyde district was originally a 160-acre tract purchased by W. H. Clarke of New York City in 1866 for $1,600. This is the Schroeder family, Fritz and Hilda, and their children, Wilhelm and Sadie, who lived in Clyde. People in studio portraits of the 19th century often appear quite solemn. Photographs required long exposures. Who could smile for a solid minute?

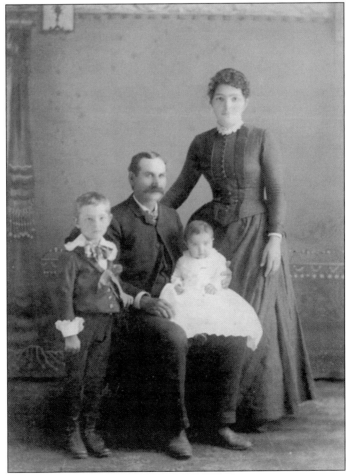

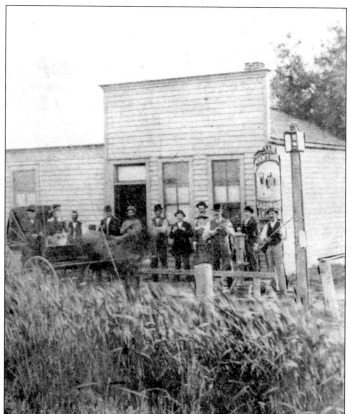

Early Cicero was a collection of small, separate settlements with great breaks of prairie in between. A single narrow wooden sidewalk often led from district to district. Although there were seldom enough girls to go around, square dances were held in the open air on Saturday nights at the Hawthorne saloon. Here local musicians tune up their instruments, around 1879, at Ogden and Cicero Avenues.

The town's location on several key rail lines encouraged early industrial development. More than any other factor, the numerous trains passing back and forth through Cicero motivated newcomers to settle in the community.

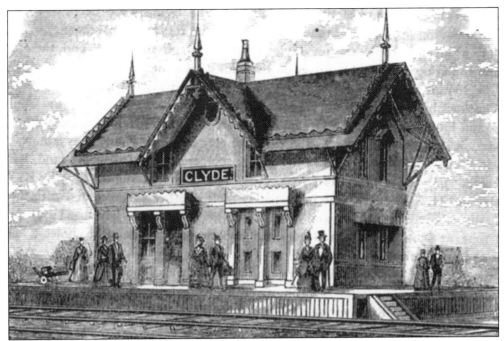

This 1873 engraving shows the Clyde railroad station on the Burlington line about seven miles west of Union Station. This popular architectural style was often dubbed "Chicago Gothic." After the busy Clyde depot was built, employees of the Chicago, Burlington, and Quincy (CB&Q) began to purchase homes in the up-and-coming village. A stop on the Metra commuter line still bears the name Clyde.

This is the Kras family home, located at 3211 Forty-ninth Avenue, a typical frame "worker's cottage" with a parlor, kitchen, and several bedrooms. Such a house could be built for $600 in the 1880s. Joseph Kras was Austrian; his wife Caroline was Polish. The house, much altered, is still standing. Forty-ninth Avenue was one of the first to be paved in the Hawthorne district.

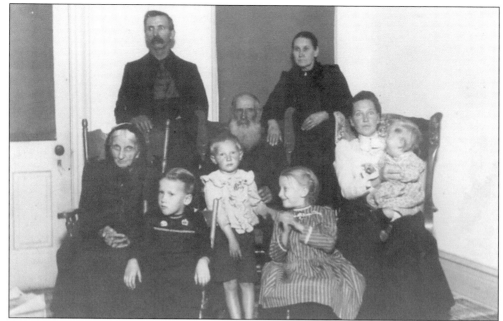

Family units living under one roof were often multigenerational in the 1890s when this photograph was taken in a cottage on Fourteenth Street. Since most workers received no pension, old age could be a challenging experience if one did not have adult children to live with. In many immigrant families, in fact, one daughter often remained unmarried to care for her aging parents.

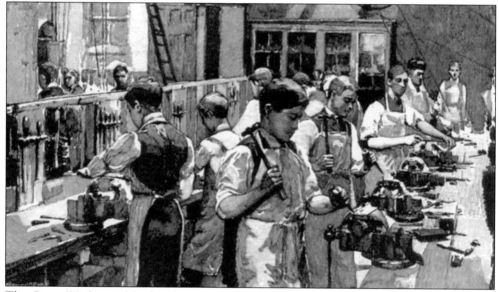

The Grant Works neighborhood, the most heavily populated area because of all the adjacent industry in northeast Cicero, was named after the Grant Locomotive Works. Some of the original 1890-era factory buildings can still be seen at Fourteenth Street and Laramie Avenue. They are in daily use by Chicago Castings. The neighborhood's early role as a port of entry continued for the next century, with successive waves of newcomers, such as the Italians (1915–1920), Appalachians (1960s), and Latinos (1980s).

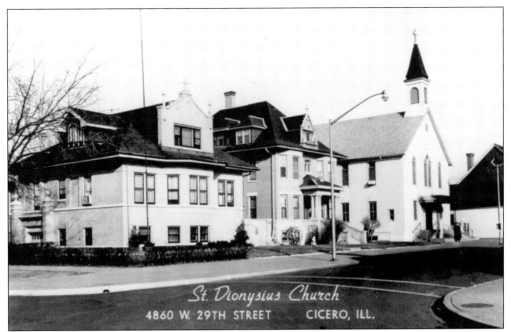

Seen here in a 1950s postcard is St. Dionysus Church at 4860 Twenty-ninth Street. The wooden structure with the steeple, the oldest church in Cicero, was constructed in 1889 at a cost of $4,000. At the time, it was the only Catholic parish between Harlem Avenue on the west and Crawford (Pulaski) Avenue on the east. The population of the Hawthorne neighborhood was then mainly German and Polish, with a few Irish families, too. The frame church was razed in 1963 and replaced. The 1990 closing of the parish ended 101 years of service in Cicero.

Summer meant three months of bare feet for children. Parts of Mud Lake were deep enough for skinny-dipping and fishing. Eventually these lowlands, with their tiny ponds and channels, would be drained for vegetable farming. This southern area later became the Drexel and Boulevard Manor sections of Cicero.

Victorian funeral customs were rigid. A proper woman's mourning costume consisted of black silk or crepe-de-chine with a bonnet draped with a thin "grieving veil" and streamers. These ready-to-wear garments were advertised at the Warren Park Dry Goods Emporium, 5805 Twelfth Street (later Roosevelt Road) in 1896. Those who came from large families were dressed in nearly constant mourning attire.

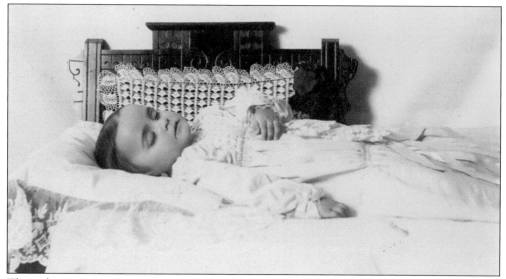

The infant mortality rate was high. Those babies who did not die from traumatic deliveries might succumb later during recurring epidemics of scarlet fever, whooping cough, and diphtheria. When a little one died, the postmortem photograph was often the only likeness of the "departed angel" the bereaved parents would ever have. Pictures were made with the child lying on his mother's lap or reclining on a sofa. This male infant has been laid out in his family's front parlor in 1892. Births, weddings, deaths, and wakes all occurred at home.

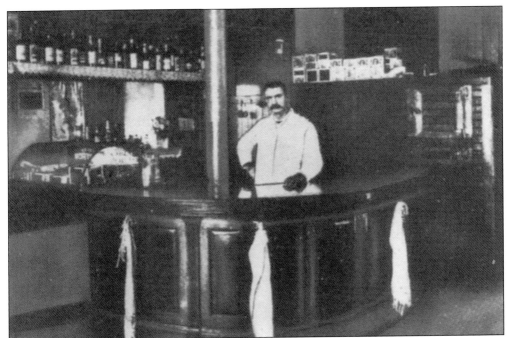

The corner saloon often provided the services of a neighborhood social center. It was also one of three males-only sanctuaries (the barbershop and livery stable were the others). Bartenders often cashed patrons' paychecks. The purchase of a drink (a nickel for a schooner of beer; a dime for a shot of whiskey) allowed access to the "free lunch" sideboard, which was usually prepared and maintained by the wife and daughters of the proprietor.

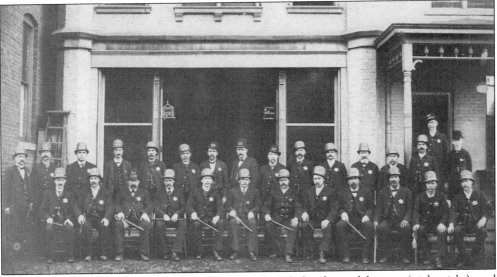

These 1890s patrolmen walked their beat armed with hard wood batons (nightsticks) and revolvers. They were forbidden to use the latter except in grave emergencies. Full-time officers wore numbered copper shields—hence the nickname "coppers" or "cops." The most heavily patrolled area was a picnic grove near Ogden and Cicero Avenues. Public intoxication, disorderly conduct, and assault and battery were the most common reasons for arrest in that era. Note the birdcages hanging in the open windows.

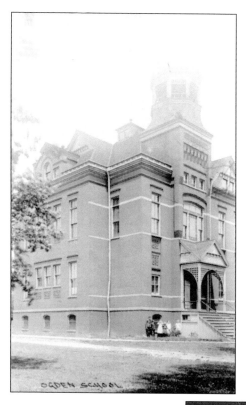

The upward-bound residents of early Cicero wanted to provide good educations for their children. So they built this red brick, towered school in 1894 at Ogden and Fifty-ninth Avenues. Both elementary and high school students were housed in this building. There were two classrooms on the first floor, an assembly room on the second, and a science laboratory on the third. When the high school enrollment grew to 44, the lower grades were moved out.

Blacksmith shops were located in all the neighborhoods during the horse-and-buggy era. Children loved to watch the smithy hammering hot metal into shapes of shoes, although most smithies also ran a sideline repairing kettles, wheelbarrows, hinges, and other hardware.

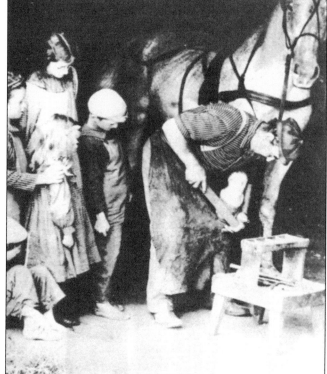

Two

THE EARLY 20TH CENTURY

In the late 1800s, a series of land annexations by Chicago resulted in a greatly reduced Cicero Township. The Austin neighborhood, for instance, was absorbed by the city in 1899. Then in 1901, Berwyn and Oak Park each split away to become separate, independent municipalities.

At the dawn of the 20th century, the surviving town retained only 5.6 square miles of its original 36-square-mile tract. But, although its territory was diminished, Cicero was booming economically.

The extension of streetcar and elevated lines, coupled with its excellent freight and passenger connections, quickly transformed Cicero into a thriving industrial suburb. The town was the largest manufacturing center in the state after Chicago, and yet marshes and wetlands still existed in the southern district. There were also open prairies and wooded groves in the central and western zones.

In the early 1900s, many of the newcomers were recent immigrants. The majority came from the Austro-Hungarian Empire (Bohemians and Slovaks), Poland, Lithuania, and Italy. The northeast Grant Works district, for instance, had a mostly Lithuanian church (St. Anthony's), an Irish parish (St. Attracta's), and a Polish parish (St. Valentine's).

Cicero became internationally known for manufacturing everything from enamel kitchenware and stoves to roofing tiles and telephones. The town's population really boomed after Western Electric, a massive plant, began large-scale recruitment of workers. Covering 203 acres, the Hawthorne Works, a virtual town within a town, became Cicero's dominant employer for the next nine decades.

There was virtual nonstop home construction in every section of the town in this period. Yet each of the settlements continued to retain its own distinctive identity and business districts. There was a high concentration of European immigrants in each neighborhood of the community.

The solid industrial base, a major source of tax revenue, allowed property taxes on Cicero homes to remain relatively low, thus making it easier for working-class people to pursue the American Dream and purchase their own single-family residences.

Twenty-second Street, later renamed Cermak Road, became the largest concentration of financial institutions anywhere in the state except on LaSalle Street in Chicago. Because so many Czechs were settling in the central section of the community, Cermak Road was often dubbed the "Bohemian Wall Street."

As the automobile was now becoming more affordable, new homes being built in more remote sections of Cicero were now equipped with indoor plumbing, electricity, and telephones.

After the Armistice ended World War I in 1918, the town's importance as a center of trade and transportation was well established. Fast-growing Cicero was also ripe for both machine politics and the entrance of a criminal element in the coming Prohibition period.

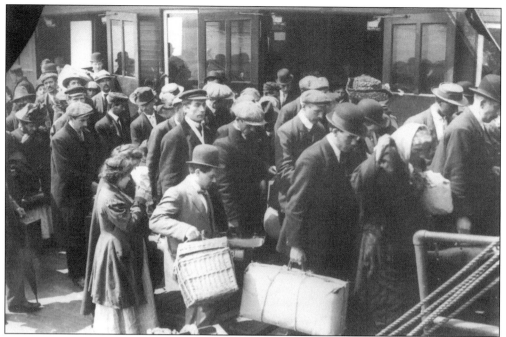

Thousands of immigrants sailed to the United States in steerage—the overcrowded, poorly ventilated compartment near the ship's rudder. Many Czechs, such as these new arrivals of 1914, first settled in a congested Chicago neighborhood called Pilsen between Halsted Street and Ashland Avenue, south of Sixteenth Street, before migrating out to Cicero.

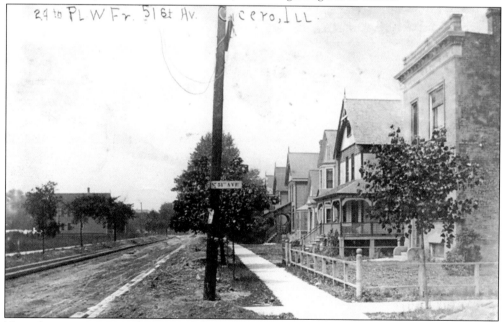

Note the narrow unpaved streets of the early 1900s. This postcard view shows Twenty-fourth Place looking west from Fifty-first Avenue. Horse manure drew swarms of flies and caused a constant stench. Children walking home from church arrived with their white shoes filthy from the mud streets.

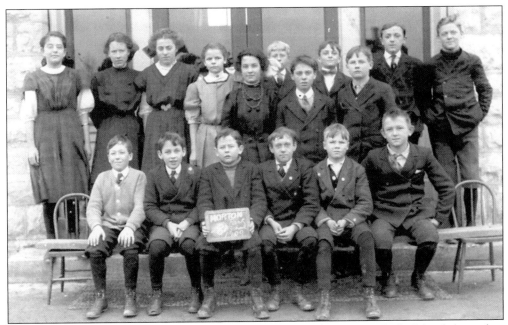

These eighth graders are members of the class of 1909 at the Morton Park School, located at 5110 Twenty-fourth Street. For many families, the annual class photograph was often their only visual record of their children growing up. Many joined the labor force right after eighth grade, supplementing their family's income until the day they left home to get married.

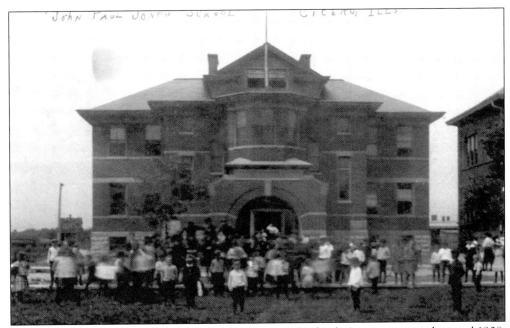

This is the John Paul Jones School, Fifteenth Street and Fiftieth Avenue, pictured around 1908. In that era, women teachers received less pay than their male colleagues. District rules strictly prohibited them from staying out after 8:00 p.m. or dressing in loud colors. They were also required to resign if they married.

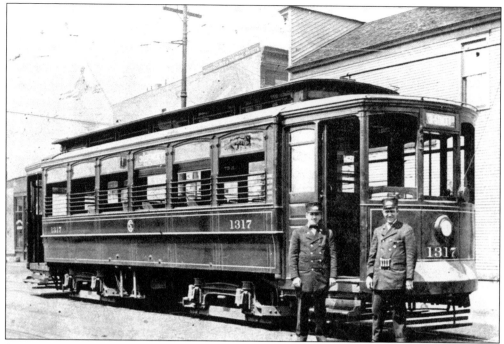

Streetcar tracks ran through the center of many key thoroughfares. Numerous Ciceronians commuted to work via the trolley. On weekends, the easy-access, cheap transportation encouraged people to go on country outings and picnics, attend concerts, or visit the cemeteries.

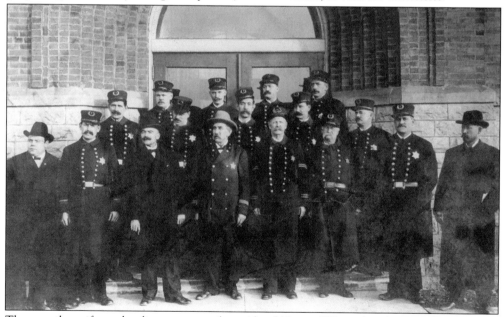

The smartly uniformed policemen were the pride of Cicero. When the photograph was taken, officers were sent out in pairs with a horse-drawn paddy wagon when hauling in drunk and disorderly young hooligans. The threat of rabies was also a constant scourge in the early 1900s, so unlicensed dogs and cats were routinely shot on sight by any officer, who was paid 50¢ for each animal he killed and buried.

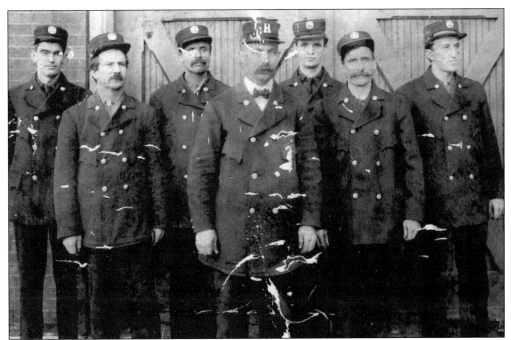

For years, Cicero's various fire brigades were made up of volunteer manpower. Beginning in 1909, when this photograph was taken, firefighters were paid $75 a month salary. Although that was considered a princely salary for the time, the men were on call in the firehouse seven days per week. They were permitted only a few hours for dinner at home with their families each day.

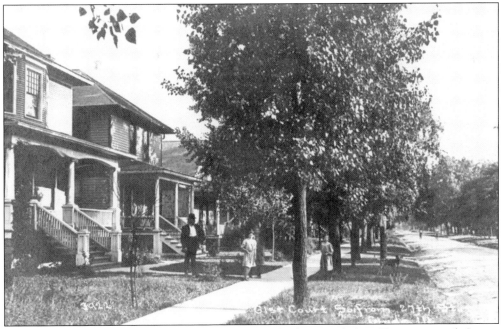

This postcard view from 1910 shows Sixty-first Court looking south from Twenty-seventh Street. These "four square" style homes were torn down to make room for the Clyde Park pavilion in the 1920s (see page 55).

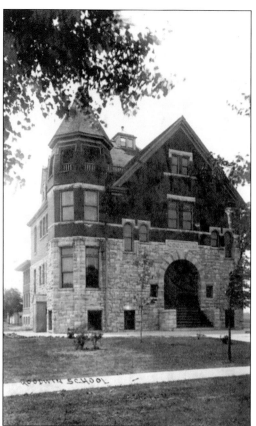

The stone Goodwin School, built in 1888 at Twenty-sixth Street and Austin Boulevard, was the first masonry-built school in Cicero. It was named for a Mr. Goodwin who owned a lot of land in the Clyde district. Students learned the four Rs: reading writing, arithmetic, and recitation. Ice-skating took place on the open lot adjacent to the school on the north.

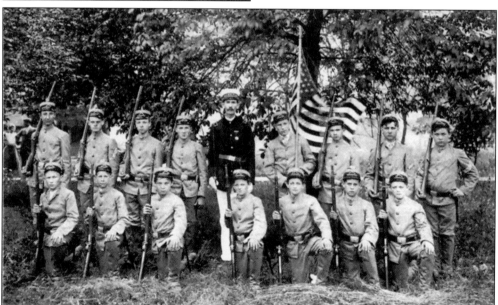

Then and now, Cicero has not only been proudly patriotic but has kept its youth busy in a variety of positive programs and activities. The Baptist Boys' Brigade in Clyde won the prize flag in a competitive drill contest on July 4, 1897.

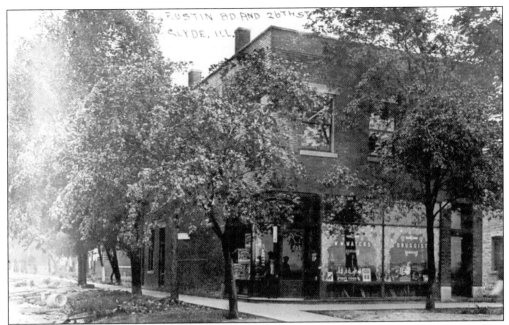

This drugstore at the southwest corner of Austin Boulevard and Twenty-sixth Street was often crammed with children from the Goodwin School across the street. In 1911, when this postcard was mailed, many residents went to the drugstore to use the pay telephone in a booth in the rear, adjacent to the soda fountain. The building is no longer standing.

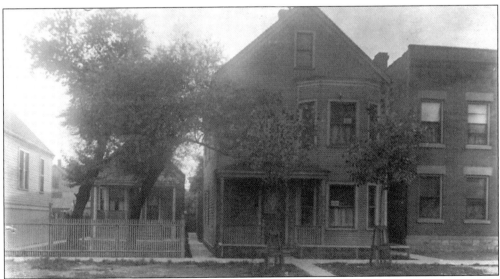

The three buildings seen in this 1910 postcard view still stand on Forty-ninth Court in the Grant Works neighborhood. The home at 1216 on the left sits far back from the street because there was a vegetable patch in the front yard; 1214 in the middle shows iceman cards displayed in the windows of both flats. On days when ice was being delivered, one indicated how much ice the deliveryman should carry to the back door.

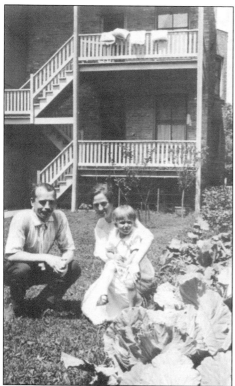

This Cicero family sits near their cabbage patch, behind their two-flat. Given the sunlight requirements of the early Kodak cameras, most pictures were taken outdoors. Snapshot photographers favored the backyard for their settings. Working-class gardens often were functional vegetable plots, seldom flower beds.

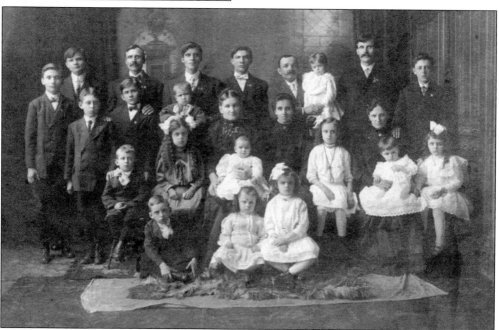

In contrast is this typical studio portrait of 1909 of an extended Polish family from the Hawthorne neighborhood. Note the formal, symmetrical pose, the stage-like setting, and the painted backdrop. Chris Pietrzak, the man with the mustache in the back row, second from left, was recently widowed. The four boys around him are his sons.

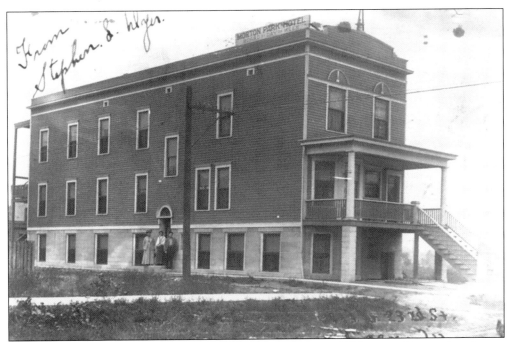

The Morton Park Hotel, 4813 Twenty-third Street, seen here in a 1908 postcard image, is no longer standing. Morton Park, established in 1888, was named for Julius Sterling Morton (1832–1902), an entrepreneur and political figure who was secretary of agriculture in Pres. Grover Cleveland's cabinet, as well as the founder of Arbor Day. Morton's name was subsequently given to the local high school (1903) and eventually the college (1924).

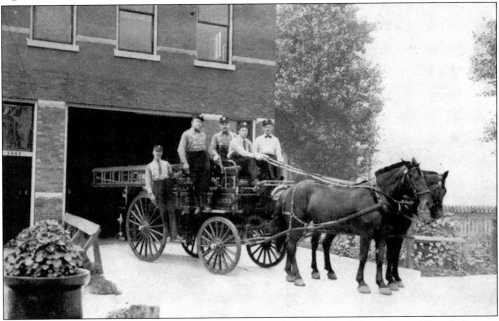

There were five different Cicero fire units, each independent of the others. This firehouse, 1342 Fiftieth Court in the Grant Works district, has functioned quite successfully in the 21st century as the headquarters of the Gang Tactical Unit of District 2 Police.

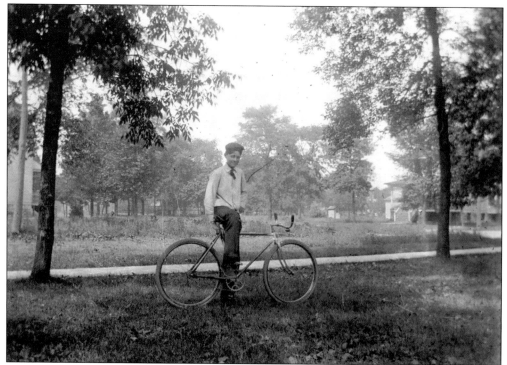

A young boy rides his bicycle through the Parkholme prairie around 1910. The area at Fifty-first Avenue and Eighteenth Street was a favorite spot for picnicking. Girls would pick wild strawberries and raspberries while boys hunted prairie chickens.

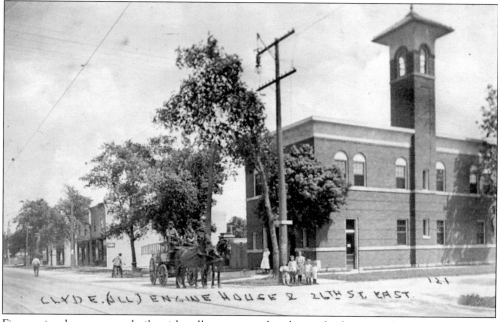

Fire engine houses were built with tall towers used to hang the hoses to dry them. This 1911 postcard view shows a gathering of children watching the Clyde firemen on Twenty-sixth Street. Although its tower was shortened, 6019 Twenty-sixth Street survives as a public safety station.

Although views of local churches, landmarks, and neighborhoods were widely popular during the postcard fad, personalized photo portraits made by itinerant photographers were also mailed out to friends and family in vast numbers. This trio of Warren Park residents posed in 1907. Warren Park was a relatively slow-growing neighborhood at the time because it had no public transportation lines.

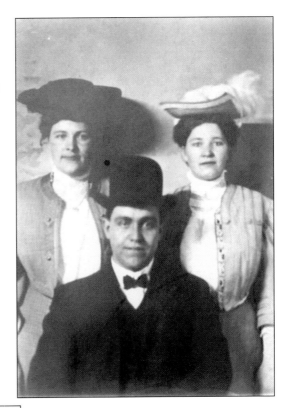

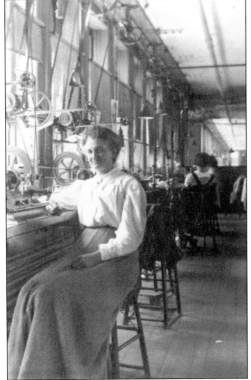

Most suburban ladies attended a virtual nonstop rotation of club meetings, teas, and luncheons. But in working-class communities like Cicero, many women were employed. In fact, around 1910, they often constituted the majority of the workers on the shop floor in several garment factories, although they were paid significantly less than men and had little access to higher-paying positions.

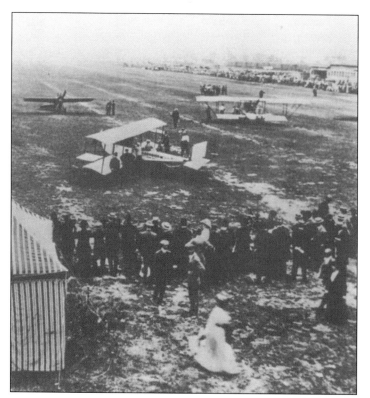

Until 1911, the Parkholme district was farmland. Opened on July 4th that year, the Cicero Flying Field became one of the first airfields in the entire Midwest. No longer did pilots need to fly from cow pastures. Cicero became, as Chicago newspapers noted, "the aviation capital of the world." The Metropolitan Elevated Railroad (later called the Douglas Park "el" and now the Pink Line) added a new station, transporting people from the Loop to the airport for just a nickel fare. The trains ran at ground level.

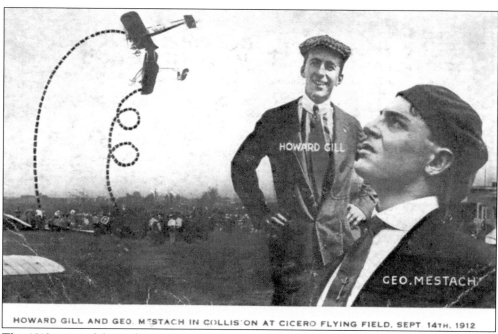

This 1912 postcard shows the tragic crash of aviator Howard Gill at the Cicero Flying Field. George Mestach collided into Gill's machine while thousands of onlookers watched in horror. Gill's back was broken; he died en route to the hospital. Mestach crash-landed but escaped injury.

Marjorie Stinson, a daring aviatrix and stunt flyer, loved to thrill the crowds who came out on Sundays for the Cicero air shows. For the 1912 aviation meet, airplane inventors Orville and Wilbur Wright went door-to-door handing out promotional flyers for this landmark event. Some 20,000 spectators showed up. Whenever they visited Cicero, the Wrights stayed on the third floor of the three-story building at 5123 Cermak Road (today next to Wendy's).

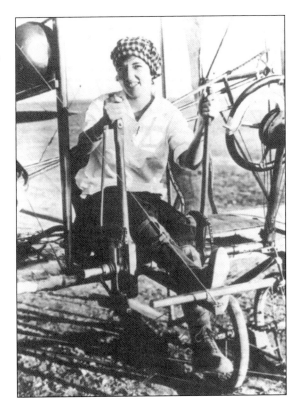

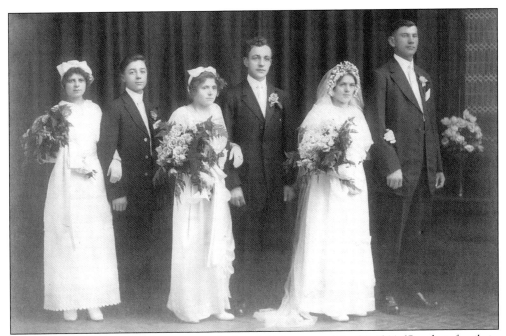

Eva and Martin Hapac (right) are seen with their bridal party on May 30, 1914. (See their family in 1927 and 1942, pages 72 and 90.) In this period, many wedding receptions were held in halls in the rear of neighborhoods saloons. With prosperity came festivities in the local community houses.

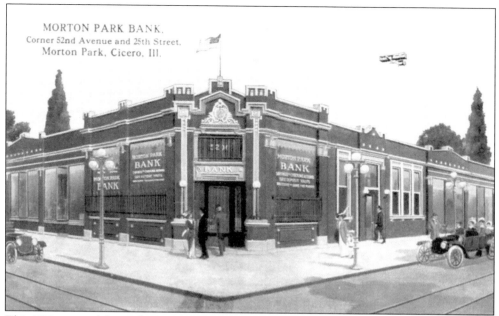

This 1913 postcard shows the Morton Park Bank, located on the northwest corner of Twenty-fifth Street and Laramie Avenue, which was replaced with a larger, more formidable structure during the booming 1920s. Note the "aeroplane" in the sky.

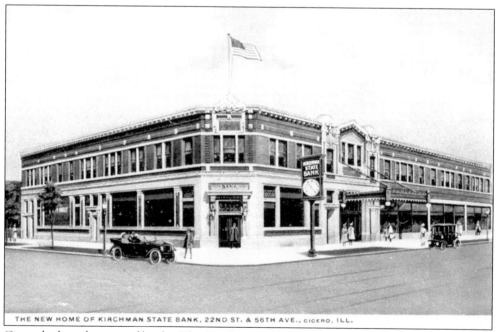

Cicero had no shortage of banks. This Kirchman State Bank, on the corner of Twenty-second Street (later Cermak Road) and Fifty-sixth Avenue, is seen in 1914. On the back, Ada wrote a tantalizing message to Mabel: "I'll be over Sunday as usual if you aren't still mad about me stealing Fred."

Postmarked 1908, this studio-made postcard image shows coworkers from the quarry posing in a prop automobile in front of a painted backdrop. Few Ciceronians owned cars at this time.

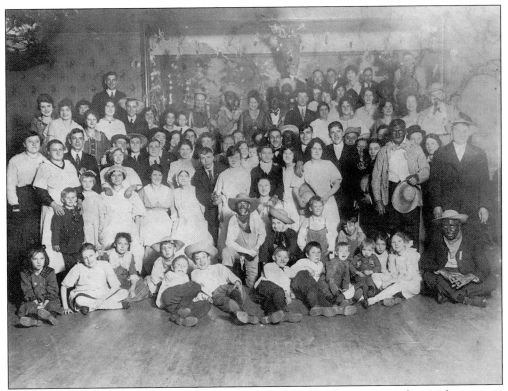

Although women and children seldom visited saloons, periodic parties and special occasions were hosted for entire families. The theme of this 1914 Morton Park barroom get-together is unknown, but many participants are in costume (some even wear "blackface" make-up).

This 1910 view of Twenty-third Street looks east from Fifty-first Court. Note the tall Western Electric chimneys in the distance. Postcard images were often shot just after dawn before the streets were crowded with wagons and pedestrians. The two-flat on the left now has wrought iron railings.

In 1906, when this postcard was mailed, the greatest share of Cicero's population was in the Grant Works, Hawthorne, and Clyde districts. Before 1907, postcards did not provide space on the back for a message, so people often jotted a line or two of correspondence on the picture side.

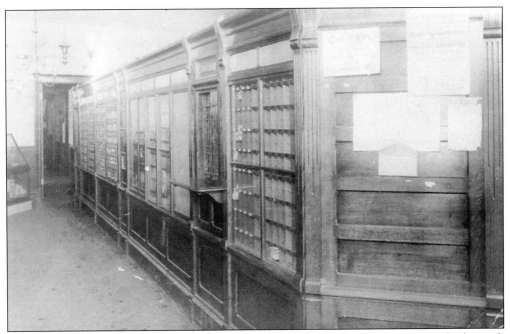

When this postcard was mailed in 1909, there was no carrier service, so Ciceronians had to pick up their mail. This is the interior of the post office on the corner of Fifty-second Avenue and Twenty-fifth Street. Mail delivery began in Cicero in 1910.

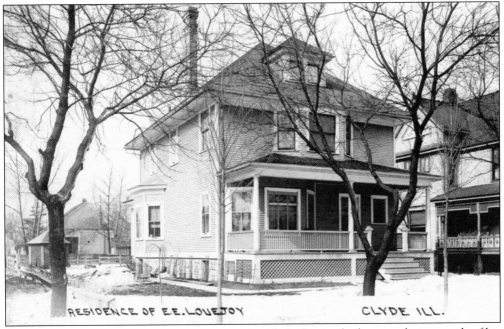

E. E. Lovejoy, a prosperous insurance agent in the Clyde district, had postcard views made of his home, 2720 Sixtieth Avenue, around 1908. The boxlike "four square" home was an unpretentious yet highly popular residential style. Typically there is a pyramidal roof, second-floor bay windows, and a broad front porch that runs the full width of the first story. The porch is now enclosed.

The first Morton High School on the corner of Twenty-fifth Street and Austin Boulevard was built in 1903. This vintage view indicates the address as Clyde, its neighborhood designation. The school facilities, with an auditorium, a gymnasium, and laboratories, were the envy of many communities.

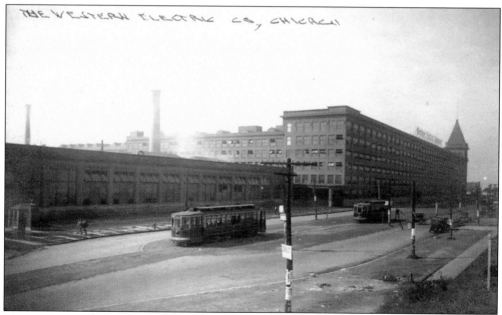

Most workers took the streetcars to work. The nickel fare may seem cheap today but workers' pay averaged less than 25¢ an hour in the early 1900s. The conductor stoked coal-burning pot-bellied stoves in the middle of each streetcar. Note the newly completed Western Electric tower (right) in this 1919 view.

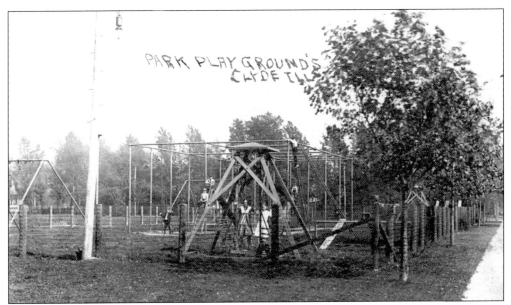

In 1907, the first public park and playground in the town was established in the Clyde district at Sixty-first Court and Twenty-seventh Street. The five-acre tract was donated to the town by the CB&Q Railroad in exchange for being permitted to build its roundhouse and yards in the subdivision.

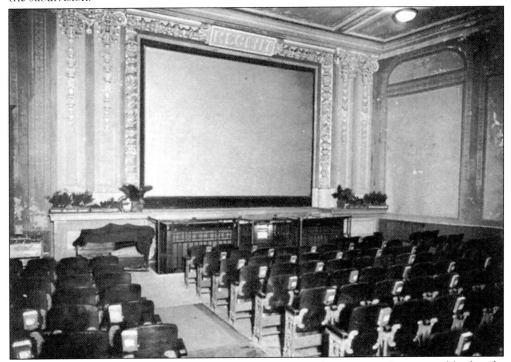

Beginning in 1913, a number of silent movie houses opened in various Cicero neighborhoods. The Annetta Theatre at 2337 Fifty-second Avenue, one of the most popular, later specialized in showing recycled "second-run" features people wanted to see again. A Salvation Army site is located at this address today.

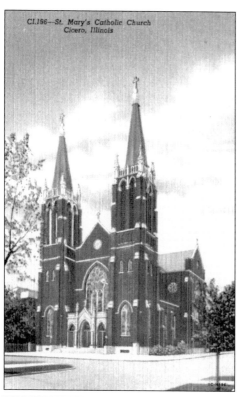

Cicero and its churches grew from east to west. When the early immigrants arrived, one of their first concerns was to build churches where they could worship in their own language. These parishes became the cornerstone of each neighborhood. The Hawthorne district was literally a prairie when St. Mary of Czestochowa Church was established. The towering Gothic spires have provided both spiritual and architectural significance for a century. Al Capone's sister Mafalda was married here in 1930.

This postcard view shows Twenty-third Place looking east from Fifty-second Avenue. Homes were often crowded in this era. It was estimated in 1911 that nearly every family in Clyde and Morton Park had three to five boarders. Many Cicero families rented rooms, meals included, for $3–$4 a week. A multicourse supper served family-style encouraged what became known as "the boardinghouse reach." Typical boarders were unrelated young single workingmen or grammar school teachers.

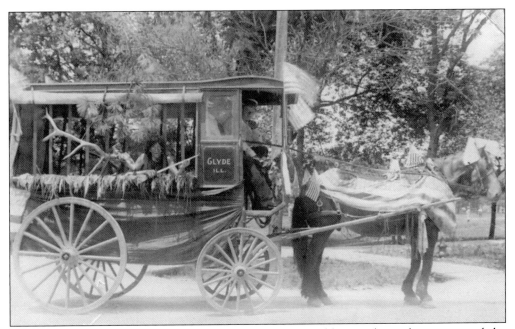

This drummer's wagon, a merchandise delivery vehicle used by traveling salesmen, served the shopkeepers in the Clyde district. It is decorated for a Cicero parade, possibly Memorial Day (then called Decoration Day) or Labor Day, around 1908.

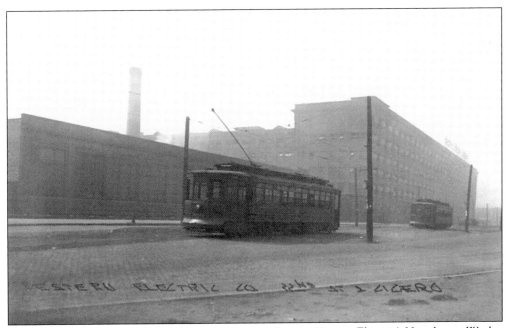

The dominant business in Cicero for over eight decades was Western Electric's Hawthorne Works, an enormous manufacturing plant at Cicero Avenue and Cermak Road that made telephone equipment. When this postcard was mailed in 1913, everyone except management was paid weekly and in cash, in individual envelopes containing the appropriate bills and change.

A series of popular postcard images in 1913 featured Cicero "lovelies." The message on the back of this one, mailed from Bruno to Floyd, says, "Hope you can join us for the picnic. We'll fix you up with Clara's sister. She's a looker!"

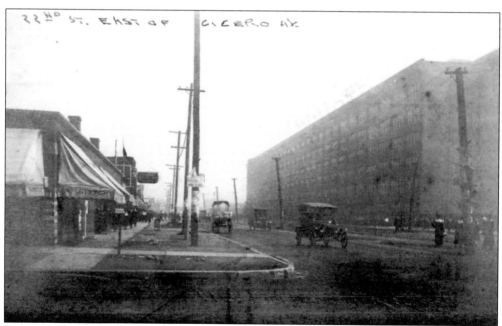

Note the closest automobile on Twenty-second Street (Cermak Road) in this 1914 view. Probably no other automobile had more impact on the daily lives of average people than the Model T Ford. Such a sturdy, reliable affordable car cost just $290. The massive Western Electric tower that became its trademark would not be built for another five years (at the right).

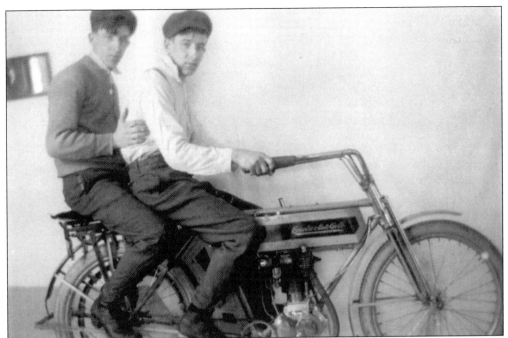

Gangs have existed in Cicero for generations. Italians and other ethnic youth gangs were often troublesome in the early 20th century. Young males had more liberty than their sisters to hang out in the street. This pair of buddies is on an Excelsior motorcycle around 1915. The daughters of immigrants were closely supervised until they became full-time wage earners. Then they gained some freedom.

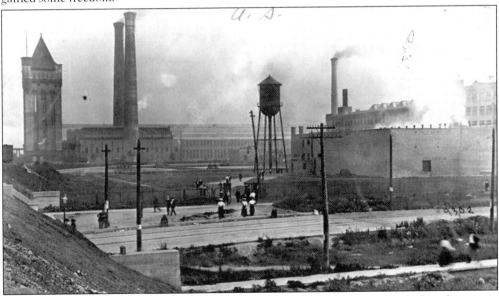

Although this 1912 postcard makes the sprawling Western Electric complex look rather gritty, the company was famous for its lawns and flower gardens. There was a gymnasium with a baseball diamond, running track, and tennis courts. The plant also had its own brass band that marched in blue uniforms with gold braid. The 1905 water tower (rear left) still stands in a shopping mall on Cicero Avenue.

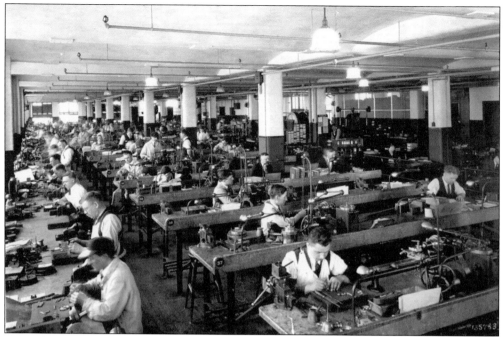

Many thousands of young immigrants went to work at Western Electric manufacturing all the telephones used in the Bell system. Note the formality of the men's clothing on the shop floor, indicating the stricter dress codes of the 1915 period.

Although many Ciceronians spent their working hours manufacturing telephones, few families actually owned one. Many used the "nickel booth" at drugstores. But by 1915, when this Bell advertising postcard was mailed, the candlestick style phone was coming into wider use and would soon be found in many Cicero homes.

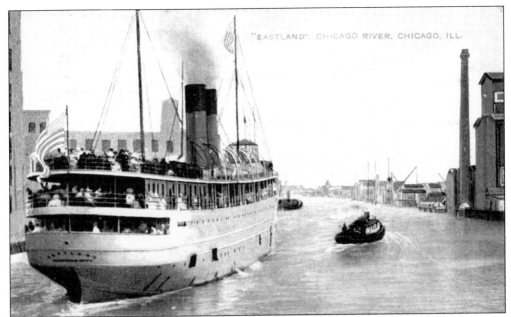

The employees of Western Electric's Hawthorne Works were looking forward to their annual outing on July 24, 1915. The company had hired a number of excursion boats to take the workers and their families down the Chicago River over to Michigan City for the day. More than 2,500 people eagerly boarded the overcrowded *Eastland* from the Clark Street Bridge at Wacker Drive. Before the top-heavy boat left the dock, it flipped over.

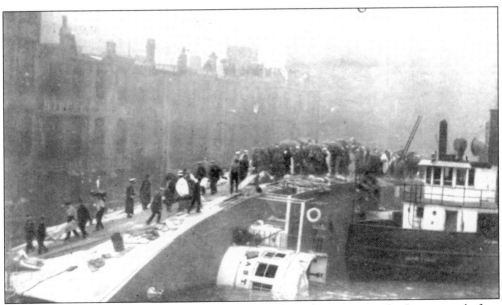

Suddenly the Chicago River was clogged with struggling, drowning people. Some stayed afloat by clutching wicker deck chairs and picnic hampers. But 844 Western Electric employees, family members, and friends drowned. After the sinking of the *Titanic* three years earlier, new safety codes required the upper deck to be equipped with many more lifeboats. Unfortunately this overloading made the *Eastland* unstable.

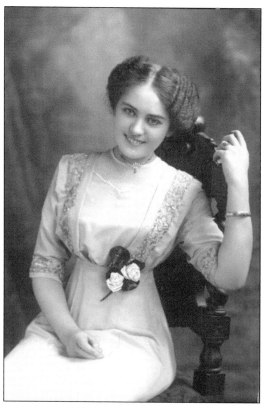

Because there were few opportunities for women in the professions other than nursing and teaching, literate women often turned to office work. Clerical jobs also paid better than other positions open to them. Although Stella Sladek looks as lovely as a showgirl, she was actually a "typewriter" in the offices of Western Electric. She was one of the hundreds who died below the deck when the *Eastland* tipped over.

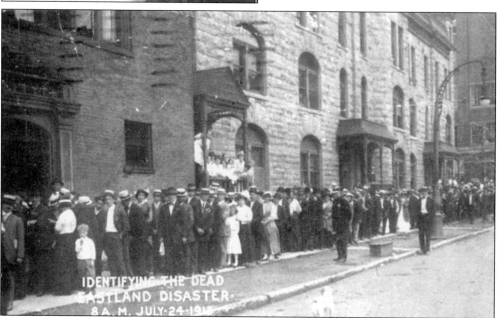

Most of the 844 victims of the 1915 *Eastland* disaster were sent to a makeshift morgue at the 2nd Regiment Armory (1054 Washington Street at Randolph Street). When funeral parlors ran out of hearses, Marshall Field's sent their fleet of motorized delivery trucks to carry the victims out to Cicero.

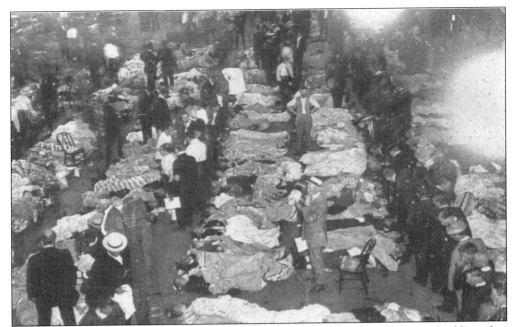

Twenty-two entire families were wiped out. Some say the renovated armory building that was used as a morgue, now Oprah Winfrey's Harpo Studios, is haunted by the spirits of the 844 drowning victims. The *Eastland* tragedy remains the largest marine disaster on an inland waterway in the nation's history.

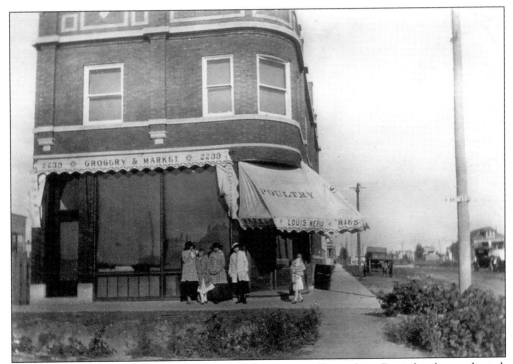

This grocery store building at 2239 Sixty-first Avenue is still standing. But it has been adapted, as so many former corner businesses have been, as a small apartment building.

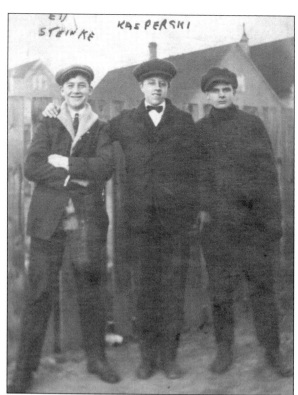

These young men are standing in the Hawthorne neighborhood around 1915. The heavy industrial base drew many young Poles to Cicero. Factory work was plentiful. Stephen Pietrzak (right) is the father of Rosemary, page 89.

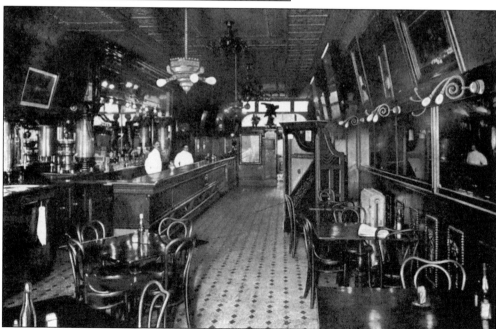

Liquor licenses provided much of the tax revenue of early-20th-century Cicero. In 1911, residents had to vote upon whether they wanted to become part of Chicago. With such a low tax rate subsidized annually by all the saloon licenses, they voted, "No, thanks." Note the tin ceiling and mechanical piano, a forerunner of the nickel jukebox.

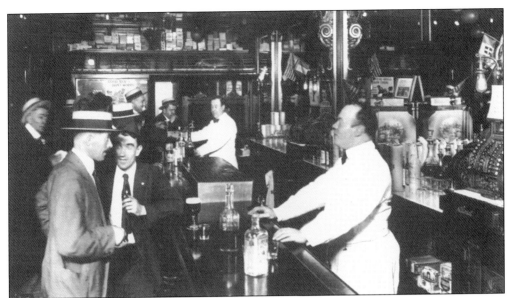

According to the 1913 telephone book, three times as many saloons existed as grocery stores in Cicero. Payday at the plants made them a little fuller. Needing release from their factory routines, men socialized, played cards, and gambled in their neighborhood saloons.

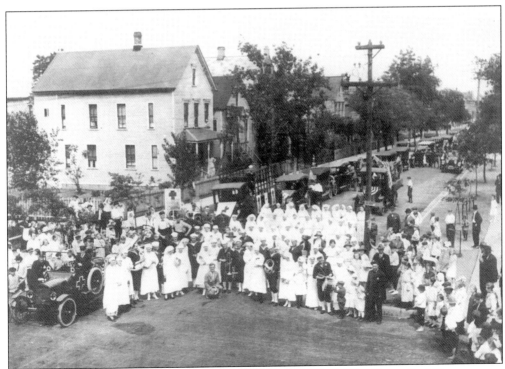

Patriotism ran high in most neighborhoods during World War I. The Cicero Red Cross stages a rally in an intersection to generate support for the war effort in 1918.

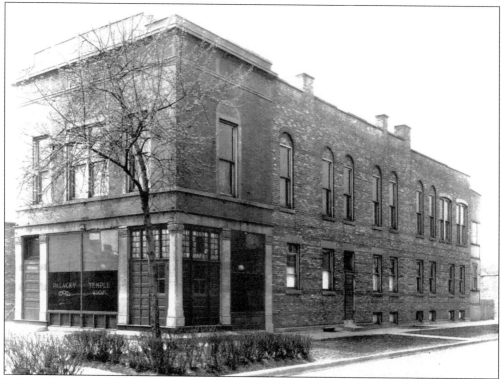

Palacky Lodge, 2100 Fifty-sixth Avenue, was a Bohemian men's organization founded for the purpose of fellowship. Such lodges were common in the first half of the 20th century. As late as 1951, there were 444 members. Today the building is the home of the Tibetan Buddhist Meditation Center.

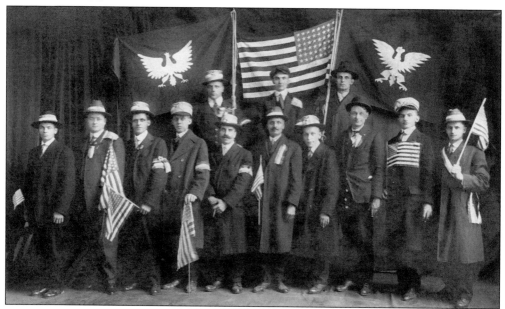

As World War I ended, the Polish White Eagle, a political and fraternal organization, posed for a patriotic photograph on Armistice Day, November 11, 1918.

Three

FROM ROARING TWENTIES TO WARTIME FORTIES

"If you smell gunpowder," they used to say in the 1920s, "you're in Cicero!"

During the Prohibition era, the production and sale of alcohol was illegal. Among those drawn to Cicero—safely outside the reach of Chicago's police—was Al "Scarface" Capone (1899–1947). "Public Enemy Number One" set up shop in 1924 at the Hawthorne Hotel, a half-block from the massive Western Electric plant. Although the 25-year-old King of the Mobsters was safe in Cicero where he virtually owned local officials, he ran his mob with an iron fist and was unforgiving to his enemies.

Old-time Ciceronians proudly recall how their parents produced "home brew" for Capone in stills hidden in backyard sheds or in their cellars. Capone's men made weekly pick-ups of the product, exchanging the full 10-gallon can with an empty one for next week. Capone was seen as a Robin Hood figure when the Depression hit. Families who had "cooked hooch" for his organization never went without a ham or turkey at holiday time, and they could charge children's shoes and school supplies at several store accounts on Laramie Avenue.

During his Cicero years, Scarface became the supreme symbol for Prohibition lawlessness. He built up a criminal network of cabarets, honkytonks, brothels, and gambling houses, reaping an annual income in the millions.

"When I sell liquor, it's called bootlegging," Capone complained. "But when my patrons serve it on silver trays on Lake Shore Drive, it's called hospitality."

For those who want to go looking for them, most of the old Capone sites are gone. His "good times house," a fortresslike tan brick three-flat that was always well stocked with booze and "party girls," still stands on the corner of 1600 Austin Boulevard, however.

During the 1920s, Cicero developed a reputation as a border town of striptease joints, all-night bars, hookers, and horse races that would last much of the century.

Yet despite the presence of racketeers in the community, Cicero was solid and thriving. The criminal activity did not have much impact on the average hard-working family. Most people went on about their business and looked the other way. Many even proudly viewed Al Capone as a fellow underdog who had overcome the obstacles of immigration and police harassment.

Because of its heavy dependence upon manufacturing, Cicero was hard hit by the Great Depression of the 1930s. The banks failed, taking many depositors' life savings with them. Unemployed hobos camped in shanties near the railroad tracks and around the dump on Thirty-first Street.

It took World War II to lift the community out of the hard times. During the 1940s, while nearly every family had someone in uniform, Cicero industries routinely surpassed their wartime production quotas. The Hotpoint factory was converted into an ammunition plant where women made 50-caliber cores for bullets. Danley Machine Specialties did war work with three full shifts, six days per week, with the plant strictly guarded against sabotage. Western Electric manufactured radar equipment and naval electronic items—not telephones—for the duration. There were bond drives, rationing, and a massive draft.

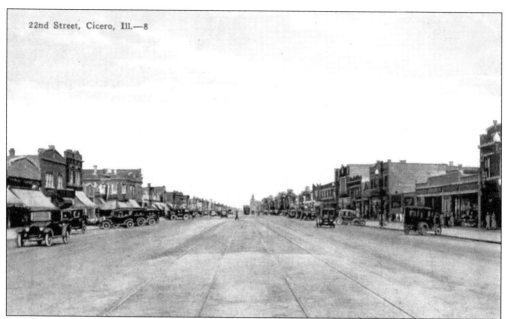

Streetcar tracks ran down the center of Twenty-second Street (Cermak Road). This 1926 postcard view looks eastward from Austin Boulevard. Note the Western Electric tower in the distant center.

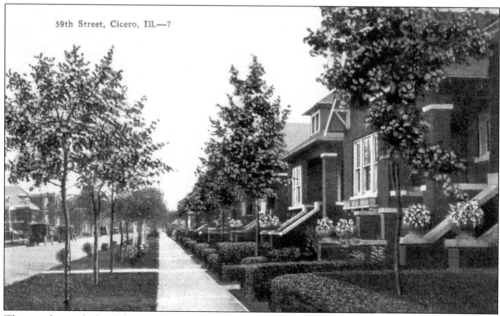

The purchase of a brick bungalow was viewed as a definite symbol of upward mobility in the 1920s. Bungalows, in fact, blurred the traditional distinction between blue-collar and middle-class families. Often costing less than $4,000, homes like these helped fulfill many people's dream of a single-family residence equipped with all the latest conveniences. (The caption indicates Fifty-ninth Street, an error. The location is Fifty-ninth Avenue.)

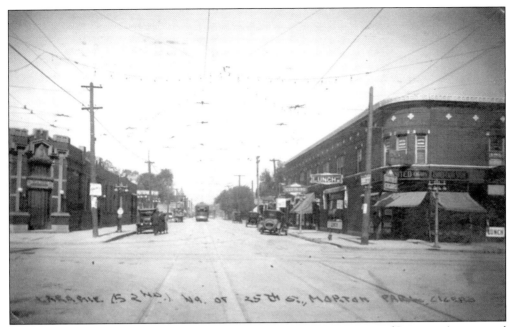

This 1923 postcard view shows the business district at the intersection of Laramie Avenue and Twenty-fifth Street, looking north. There were lunch counters, druggists, dress shops, meat markets, a movie house, and a dime store in the vicinity. None of these buildings still stand. The Annetta Hotel (below) would be constructed a block north in the following year.

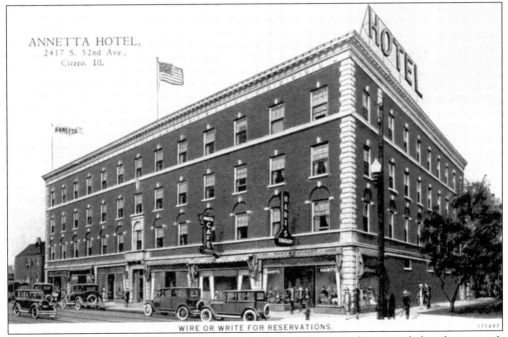

The Annetta Hotel at 2417 Laramie Avenue, built in 1924, was often crowded with racetrack patrons. Today it stands boarded up and abandoned. The caption of this 1929 postcard refers to the 150-room hotel as "A Home For Traveling Salesmen For $2 A Night."

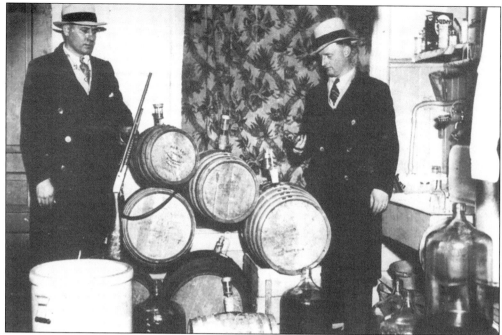

During Prohibition (1920–1933), it was illegal to manufacture, sell, or transport alcohol. So people began to make, sell, and buy liquor in secret. Gangsters gained control of many of these illegal activities. Although Federal Agents periodically went through the motions of confiscating their bootleg liquor and distilling equipment, the Al Capone operation would soon thrive, expand, and increase its territory.

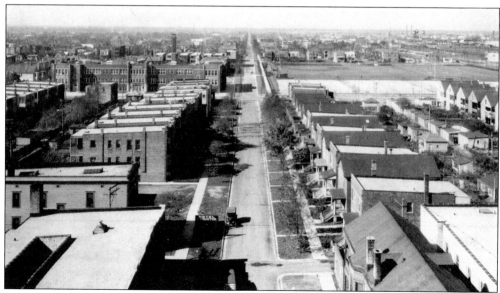

Looking west from Cicero Avenue, this photograph shows how densely populated the eastern section of the town had become by 1922. One third of the housing units were two-flats—long, rectangular buildings with their narrow side toward the street. Immigrant families often invested in these two-story housing units, occupying one apartment themselves and renting the other to relatives.

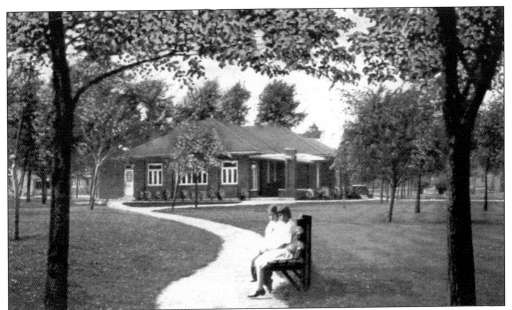

Cicero officials took great care to establish and maintain parks and playgrounds. This quiet Clyde Park pavilion scene replaced the "four square" homes seen on page 25. Playground reform, a progressive movement, strove to provide children with safer, cleaner places to play than in the streets and alleys.

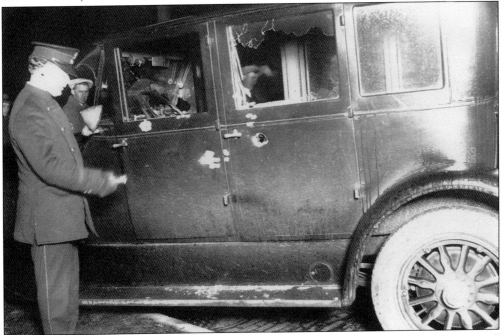

Meanwhile, the Capone mob successfully eliminated their competition during the "beer wars," which were bloody battles over distribution turf. Few of the killers were ever apprehended, however. Bribe money changed hands, witnesses were intimidated, and hoods never testified against one another. Yet for the average working family, Cicero was a safe and prosperous community during the 1920s.

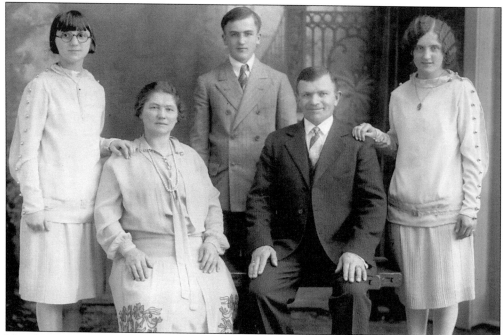

Note how well dressed the Capak family appears. The parents, Mary and George Sr., are seated. The children are standing (left to right): Emily, George Jr., and Mary. Cicero residents worked hard to provide advantages for their children.

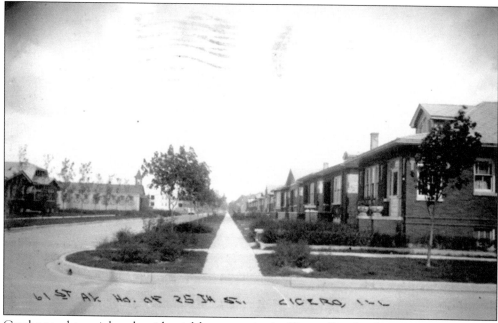

Czechs sought social and residential homogeneity in Cicero. For the first time in their lives, many families owned their own homes—single-family, detached houses on quiet, tree-lined streets. Their brick bungalows replaced the frame cottages of the previous generation as the dominant working-class residence. Note the newly planted elms on Sixty-first Avenue, just north of Twenty-fifth Street.

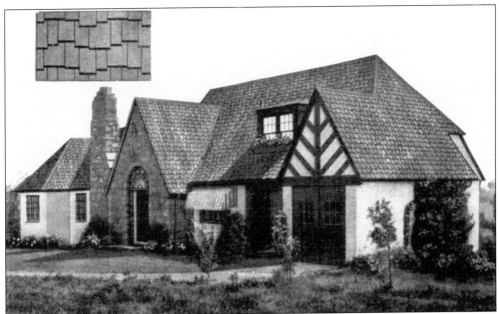

Bungalows were solid, practical homes laid out to accommodate growing families. There was a wide range of stylistic variation, depending on the taste and budget of the homeowners, from Spanish tile roofs to art-glass bay windows. This advertising postcard was distributed by the Hawthorne Roofing Tile Company, 5856 Ogden Avenue. Their tagline was "This is the roof that outlasts the foundation."

Flappers were up-to-date young women with bobbed hair and short skirts. These high school girls, Emily Capak (see page 56) and Ann Haberna (right), pose at Fourteenth Street and Fifty-second Avenue around 1927. Amateur photography had grown in popularity. Anyone could use a Kodak box camera. No longer did people have to go to professional photograph studios or arrange for an itinerant photographer to come out to their house. The automobile had also grown in importance, so the family car was often featured as a prop in lots of snapshots.

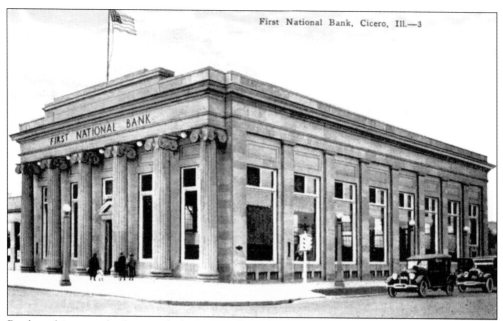

Bank architecture had to symbolize strength and security. The First National Bank located at Twenty-second Street (Cermak Road) and Austin Avenue was praised for its classical beauty, symmetry, and two-story Ionic columns. The Fifth Third Bank now occupies this historic structure.

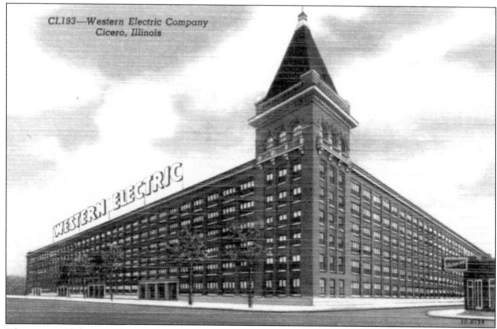

The tower of the massive Hawthorne Works plant of Western Electric stood 183 feet, 10 inches high (seven stories). A symbol of pride for generations, it reminded people of a castle or a cathedral in a medieval European city. The company was truly a town within a town, with its own railroad yard, hospital, orchestra, and park.

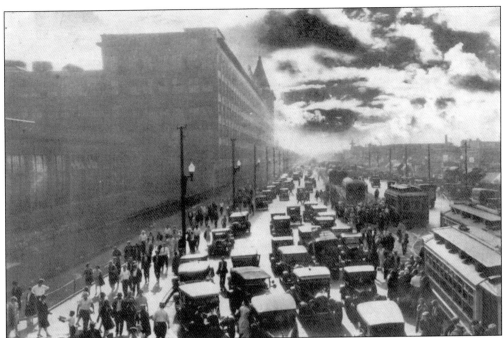

Looking west on Twenty-second Street (Cermak Road) in 1929, one sees the mass exodus of workers at the end of the first shift. Off-the-job Ciceronians tended to flock together by ethnicity, but according to Western Electric's publicity of the period, at the plant "all groups work together and do what their department chief demands."

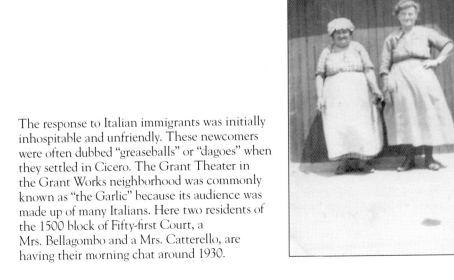

The response to Italian immigrants was initially inhospitable and unfriendly. These newcomers were often dubbed "greaseballs" or "dagoes" when they settled in Cicero. The Grant Theater in the Grant Works neighborhood was commonly known as "the Garlic" because its audience was made up of many Italians. Here two residents of the 1500 block of Fifty-first Court, a Mrs. Bellagombo and a Mrs. Catterello, are having their morning chat around 1930.

The First Duty of an American Citizen:
VOTE TUESDAY APRIL 8, 1924

The banner is from the 1924 Cicero election during which Al Capone sent out 200 armed men to oversee the voting. Many voters who initially refused to be intimidated were pummeled until common sense prevailed, and they voted for the candidates Capone wanted. Automobiles with armed gunmen sped up and down the streets. Despite police efforts, Cicero was about to become "Caponeville." Soon everyone from local businessmen to public officials would be taking instructions from the Capone headquarters.

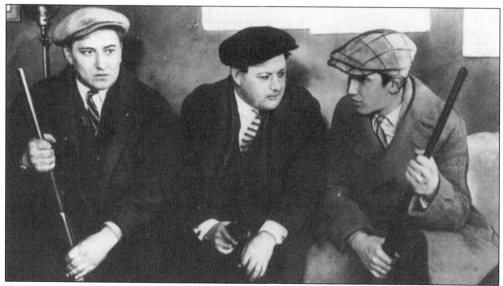

An armed guard was set up at the Democratic Party headquarters and polling places after they were invaded by Capone's thugs on Election Day in 1924. In one of several shoot-outs that day, Al's brother Frank was killed by police officers. All saloons and speakeasies in town closed to show respect during his funeral, which was said to be the driest period the town experienced during Prohibition.

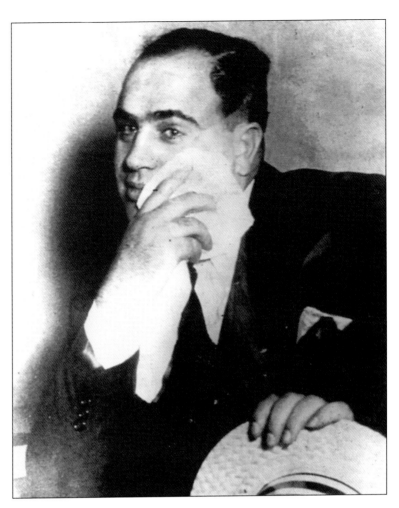

Scarface was always touchy about the gash across his left cheek. But it never cramped his style when he went into action. Capone was said to break up meetings of the town council and personally silence critics and newspaper editors with his blackjack. After town president Joseph Klenha voiced an inclination to "clean out the riffraff," Capone paid a visit to town hall, slapped the mayor around, and literally knocked him down the steps. The mobster kingpin then put him on his payroll. Klenha and his family lived in 1837 Austin Boulevard.

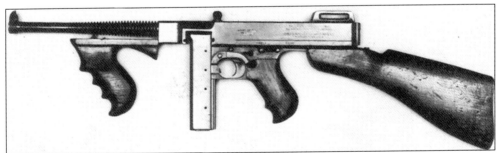

Al Capone was not the first gangster to shoot a Thompson submachine gun, which was developed for use in the trenches of World War I, but he perfected its use during the Prohibition beer wars. Quick and concealable, the "Tommy Gun" became a primary symbol of the Roaring Twenties. On April 24, 1926, Pearl Wilson's beauty parlor at 2208 Austin Boulevard was sprayed with bullets. James "Fur" Sammons, a Capone rival, was the suspected target. The building is still there.

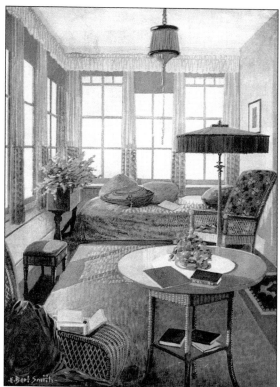

Previously back porches were used primarily as utility rooms. This illustration from a c. 1924 bungalow sales brochure introduces the sun parlor, which could double as a guest room or a hot weather sleeping room.

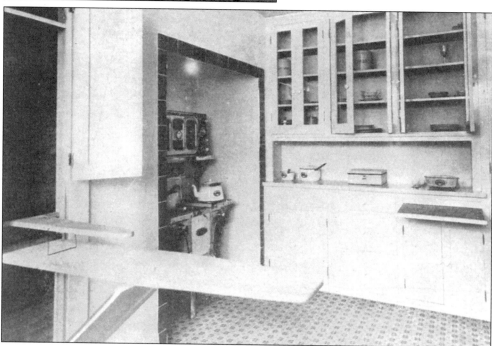

Compact bungalow kitchens of the 1920s represented the height of modern efficiency, convenience, and sanitation. Note the handy-dandy built-in ironing board with its own closet. These shallow cupboards have often been adapted as spice cabinets by modern homeowners.

Al Capone rode around Cicero in a specially constructed chauffeur-driven, bulletproof Cadillac touring car that cost $25,000 and weighed seven tons. He was always preceded by one car filled with bodyguards and followed by yet another.

A streetcar in the distance heads west on Twenty-fifth Street near Fifty-third Avenue. At this time, Al Capone occupied an entire floor of the three-story brown brick Hawthorne Hotel located at 4833 Cermak Road. During a bloody shoot-out on September 20, 1926, rival gangsters pulled up in touring cars and shot up the place with machine guns in broad daylight. Capone, enjoying his breakfast in the hotel dining room, hit the floor and escaped harm.

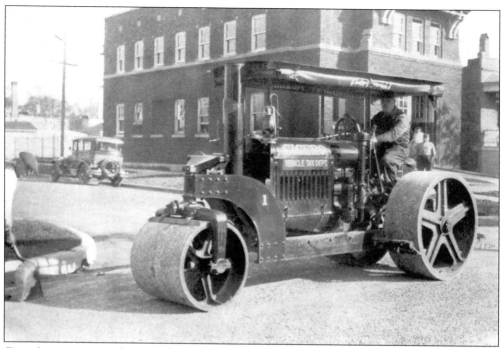

Cicero's streets were always well maintained. This three-ton gasoline roller was used in street repair work around 1929.

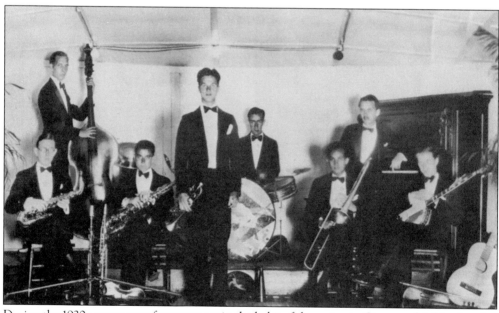

During the 1920s, many out-of-towners got in the habit of slumming in Cicero—drinking bootleg booze, rubbing shoulders with "hoods" and racketeers, and dancing to hot jazz. Most of the players of Husk O'Hare's Wolverines, a popular jazz band that often performed in Cicero speakeasies, were Austin High School graduates. Jimmy McPartland (center, standing) played cornet.

In 1928, these low-waisted crepe frocks were selling for $4.95 at Madame Slavka's Fashion Shoppe, 6038 Twenty-second Street. The smartly dressed flapper set wore their helmet-like cloche hats pulled down over their bobbed hair to their eyebrows.

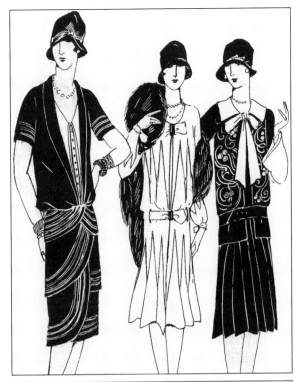

Although in 1900, folks in Cicero enjoyed singing around their player piano in the parlor, by the 1920s—the Jazz Age, an era of "phonograph fever"—they now danced around their Victrola. The hand-cranked record player became a virtual household necessity. One could buy a recording of the top performers of the day for 25¢.

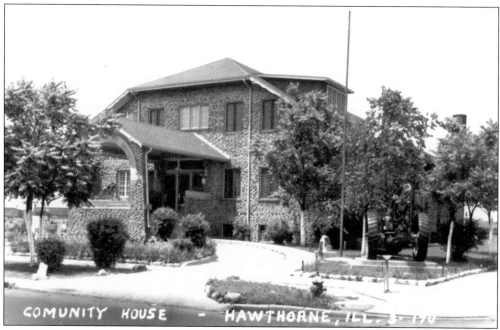

The Hawthorne Park Community House, seen here in a 1930 postcard view, is still used every day for a wide range of programs and activities. It is located on Twenty-ninth Place at the south foot of the Laramie Avenue Bridge.

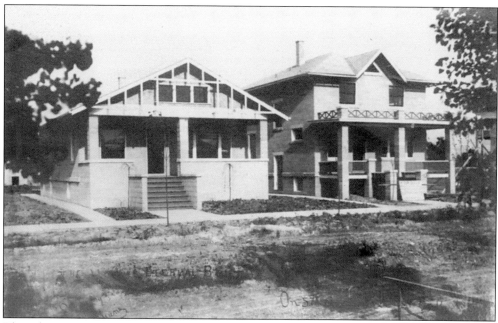

These homes, under construction on Fifty-seventh Avenue between Fifteenth and Sixteenth Streets, are featured on an advertising postcard mailed out by a construction firm. Its message was printed in both English and Czech.

The Crown Stove Works, 4631 Twelfth Place, was one of the first factories to move into Cicero. Originally the plant made cast-iron wood-burning stoves, but by 1929, the date of this advertisement, enamel gas ranges were their biggest sellers.

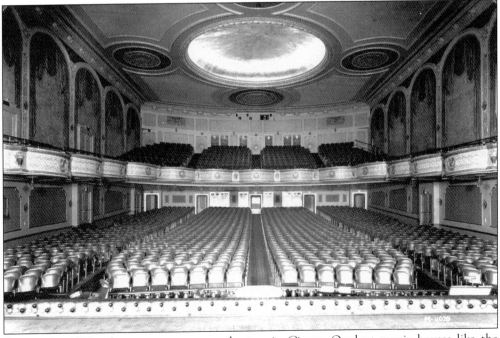

During the 1920s, there were numerous theaters in Cicero. Opulent movie houses like the Palace, 5240 Twenty-fifth Street, never failed to awe audiences with their classy décor. Unable to compete with television, the Palace Theatre was converted into the Palace Bowl in the 1950s. Today this site is a parking lot.

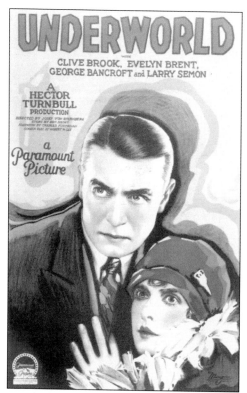

This lobby card for *Underworld*, a silent movie hit of 1927, is from the Villas Theatre, 5603 Cermak Road. When Al Capone went to the Villas, it was said he arrived with "a bodyguard of 18 goons" who sat all around him during the show. The Villas was torn down in 1960.

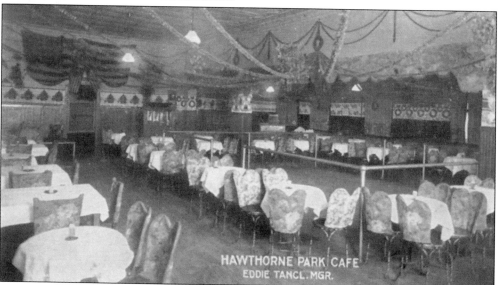

During Prohibition, gangster-controlled speakeasies replaced traditional saloons. Rival gangs continually battled over turf to determine who would be sole supplier of the illegal alcohol. These saloons were listed in phone directories as "soft drink parlors" or "eateries." There was no need for passwords ("Joe sent me" was common elsewhere) because the police rarely enforced the 18th Amendment. This cabaret, the Hawthorne Park Café, offered a floor show that included top-notch jazz bands and Charleston dance contests. Most of the fun-seekers who visited these establishments were not Cicero residents.

Fred Dahn and Clara Laube were German Americans who were married at Redeemer Lutheran Church, Twenty-third Street and Fifty-third Avenue, in 1922. Formal wedding portraits had become widely popular but were usually taken sometime after the ceremony in the photographer's studio. Clara is probably holding an artificial prop bouquet.

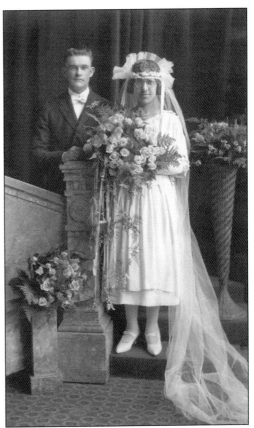

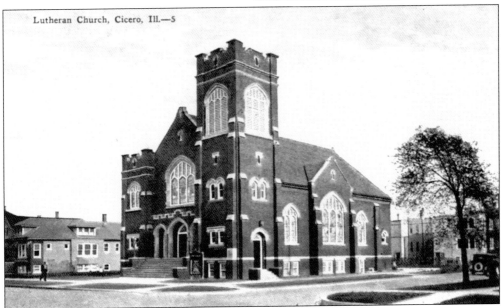

Seen here in a 1920s postcard view is Redeemer Lutheran, a red brick church at 5247 Twenty-third Street. The congregation had begun meeting in a storefront, 5113 Cermak Road, in 1912. In 2006, the structure survives as the Ark of Safety Apostolic Faith Temple.

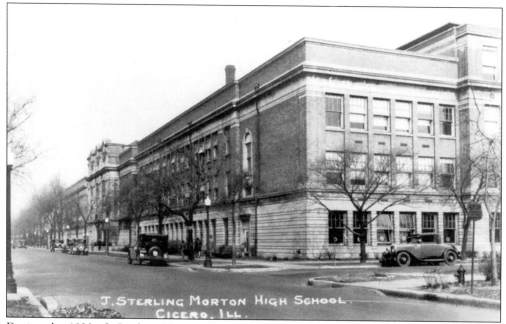

During the 1920s, J. Sterling Morton High School became the largest in the state, hailed for its progressive curriculum and advanced methods of instruction. Its total enrollment of over 7,000 students included the student body of Morton Junior College (on the third floor).

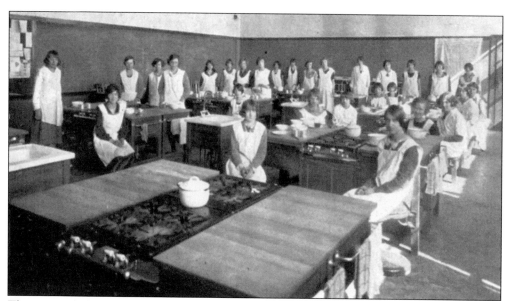

The caption below this 1929 yearbook photograph says, "From simple dishes to menus for family banquets, Morton's domestic science students are prepared to be successful housewives. To pass sewing the girls are required to make their own graduation dresses."

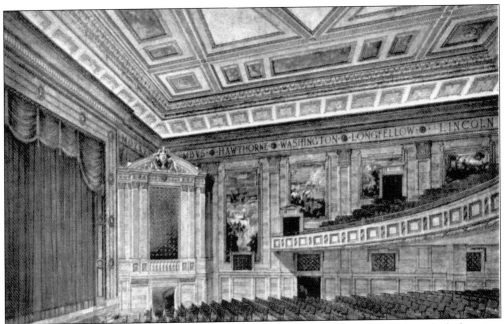

The massive Chodl Auditorium of Morton High School, named for longtime board of education president Edward Chodl, is now on the National Register of Historic Places. The stage is so large it was used for Suburban League basketball games. There is a seating capacity of 2,680. The Chodl is the largest non-commercial theater space in Illinois. Huge murals illustrate the early history of America.

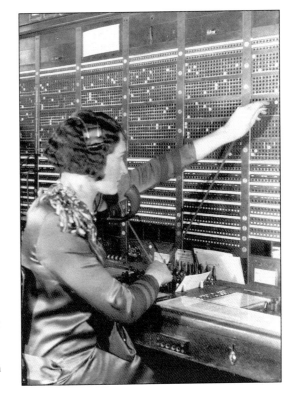

In 1926, the new Cicero telephone service building at 6125 Twenty-sixth Street began servicing the community. Hundreds of women were hired as telephone operators to manually connect callers. Although Bell regulations strictly forbade monitoring phone calls, eavesdropping was a constant temptation in the days before automatic dialing.

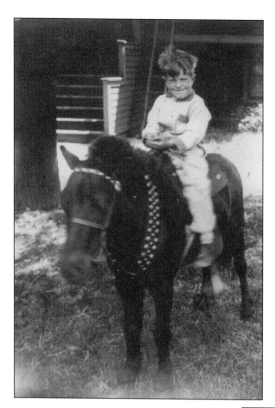

This pony made the rounds of Chicagoland with an itinerant photographer. In 1928, Artie Dahn, known by his folks as "Buddy," had his picture taken in front of his home, 2335 Fiftieth Avenue. (See Dahn's parents, page 69.)

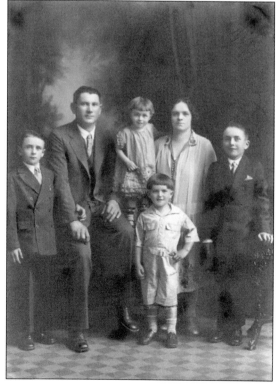

The Hapac family (see wedding, page 33) had four children in 1927 when father Martin opened his saloon on Laramie Avenue in the middle of Prohibition. From left to right are Bill, Martin Sr., baby Mary, Eva, and Martin Jr. Joe, in short white pants, stands in front. Mr. Hapac was Croatian; Mrs. Hapac was Slovak.

Morton High School was hailed for its advanced curriculum and its progressive methods of instruction. Yet there was a definite emphasis on vocational preparation. Morton's enrollment continued to swell in the 1930s. Not only had Cicero grown in size, but also there were fewer jobs to lure young people into leaving school early during the Great Depression.

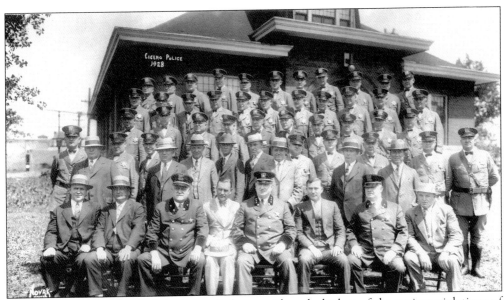

The police force of the Prohibition period was said to do little to fight against violations of the anti-liquor law. In fact, for many saloon keepers, cabaret owners, and those manufacturing bootleg booze, police bribery was viewed simply as a necessary business expense.

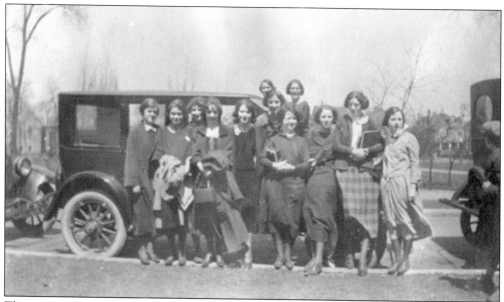

These young flapper coeds were some of the first freshman students at Morton Junior College on the third floor of the high school in 1924. Since 1975, the school has its own campus on Central Avenue just north of Pershing Road.

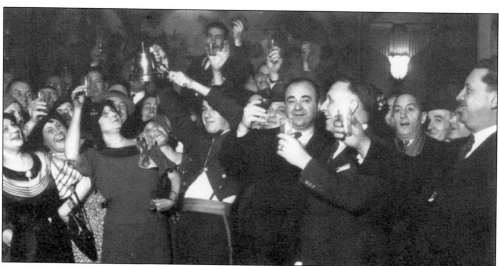

Bartenders are pouring a round of legal drinks in celebration of the repeal of the 18th Amendment in December 1933. Prohibition was over! The Mob then branched out into slot machines, jukeboxes, and cigarette vending machines. Soon the word saloon also dropped from use. Cocktail lounge or tavern replaced it.

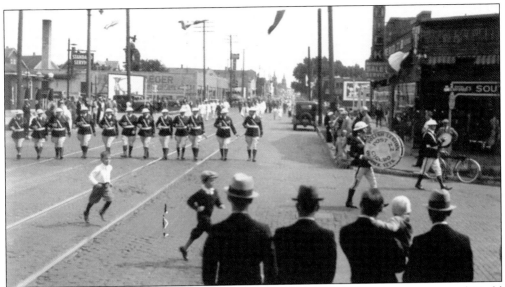

Ethnic pride was a great source of strength in Cicero. Here Polish American veterans of World War I are marching in a Labor Day parade during the Great Depression. Note the boys running across brick Cermak Road and the streetcar tracks. Male children wore short breeches or "knickers" into adolescence in the 1930s.

Because of its heavy dependence upon manufacturing, Cicero was hard-hit by the Depression. Thousands of Western Electric workers, many with decades of service, were handed their walking papers. Yet there were fewer home foreclosures than in other communities in the 1930s.

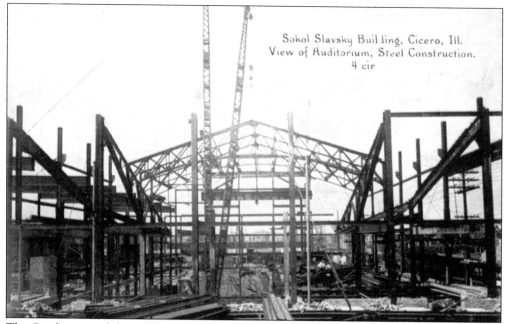

The Czechs created the network of physical fitness and community centers called Sokols. The Sokol Slavsky on Cermak Road at Lombard Avenue was the largest Sokol unit in America. Here it is under construction in 1926. Adult membership was 985 men and 470 women in its early years. The building sported one of the most modern gymnasiums of the era as well as a huge auditorium and swimming pool. An average of 450 gymnasts attended classes each evening.

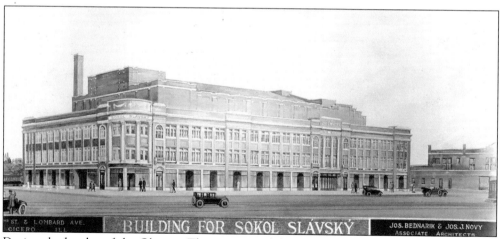

During the heyday of the Olympic Theater, part of the Sokol Slavsky complex, big vaudeville shows and large-scale Czech opera productions were presented on the 36-foot-deep stage. The biggest of the "big bands" all played here, too. Although the large block-long building still bears the name "Sokol Slavsky," the Czech fraternal and physical fitness organization no longer functions at this site. It is now a banquet hall and live theater venue called Concordia.

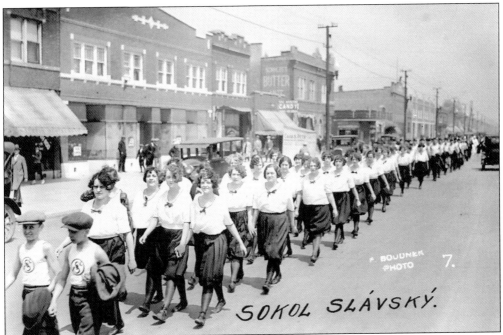

These young people marching along Cermak Road in the late 1920s are members of the new Sokol Slavsky. One began Sokol classes at age three. All programs were conducted in Czech. The premise was that a sound mind is easier to possess if you have a sound body. Note the heavy serge bloomers, standard athletic attire for girls in that era.

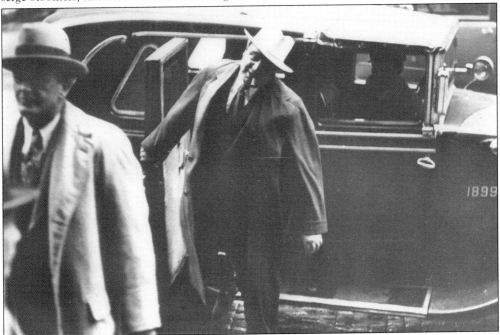

Lifelong senior residents of Cicero recall that during their Prohibition-era childhoods, Cicero was virtually free of petty crime. Small-time crooks and street thugs vacated the community out of fear of retribution from Al Capone's enforcers, often said to be far worse than any cops.

Pres. Franklin Roosevelt fought the Depression by engaging in relentless experimentation. During the 1930s, the Blue Eagle signs of FDR's National Recovery Act (NRA) with the slogan "We Do Our Part" were seen in merchants' windows all across Cicero. Note the eagle symbol in the upper left corner of this advertising postcard. Some of the NRA's legacies remain, such as shorter working hours and the five-day workweek.

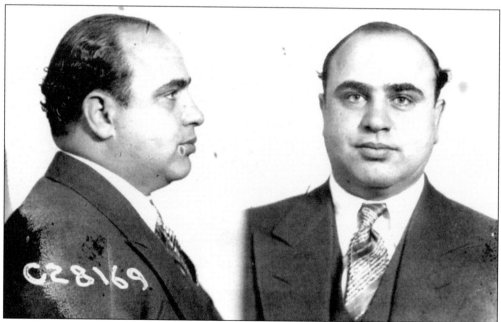

Although Al Capone was cocky and confident that he would easily beat the rap, a Treasury Department investigation in 1931 led to his conviction of failure to report his income and pay taxes. These mug shots were taken after the 32-year-old was indicted by a federal grand jury. After Capone went to prison, his Hawthorne Kennel Club, a dog racing track, was converted to horse racing as Sportsman's Park.

Many families escaped the Great Depression by listening to the radio. The Excello Midget Radio-Phonograph, manufactured in Cicero, is seen here in a 1931 advertising postcard. This walnut-trimmed table model had six tubes and an illuminated dial. It cost $68. The Excello building, 4830 Sixteenth Street, is now home of the Urban Elevator firm.

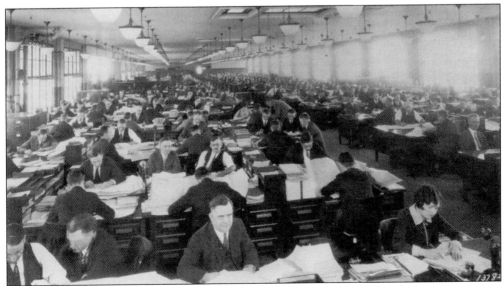

Between 1924 and 1936, the landmark Hawthorne Studies, which launched the human relations movement in management thinking, were conducted at Western Electric by the Harvard Business School. Researchers interviewed 21,000 employees at the plant. The studies brought about a better understanding of the effects of working conditions on worker productivity.

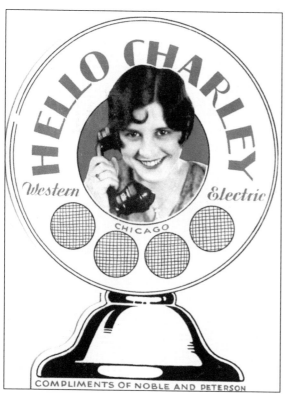

The crowning of the Hello Charley queen was part of a tradition of Western Electric beauty pageants that lasted from 1930 to 1980. This automobile windshield sticker shows Jean O'Rourke of the Hawthorne neighborhood, the first winner in 1930. Each year, over 25,000 stickers featuring the winning Western Electric employee were distributed. This 50-year tradition fostered camaraderie and a bond among the workers. Whenever Western employees spotted another automobile bearing a Hello Charley microphone emblem with the pretty young girl on it, they honked in solidarity.

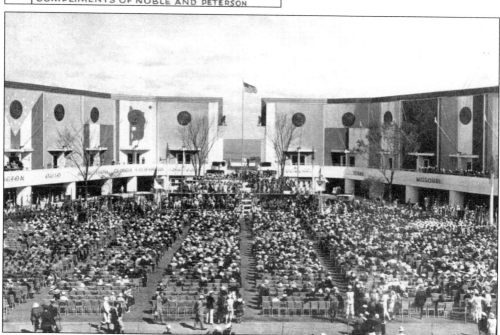

In the depths of the Depression in 1933, Chicago celebrated its centennial with the Century of Progress exposition sprawled along the lakefront. Visitors to the world's fair were excited by the modernistic art deco buildings. In September, a special Cicero Day paid tribute to the town; the festivities included a Sokol demonstration and an accordion band concert.

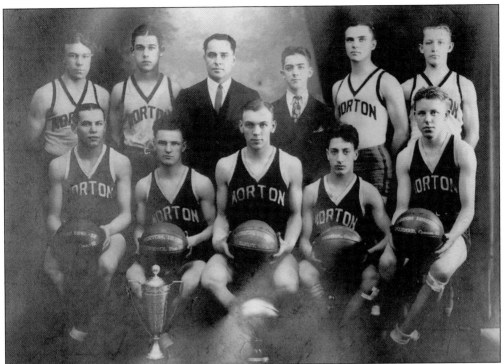

Morton High's prominence in athletics was displayed by the achievement of its basketball team in 1927, when it won the National Championship by beating Kansas City. There was a celebration in Cicero that lasted the entire week. The five players in front were the starting lineup (from left to right): Louis Rezabek, George Fencl, Edward Kawaski, Michael Rondinella, and Ossian Nystrom.

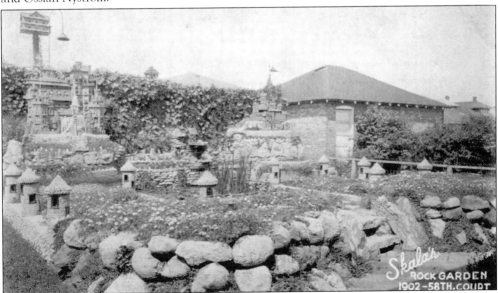

Every Cicero neighborhood held its wonders and curiosities. Behind his bungalow at 1902 Fifty-eighth Court, Frank J. Scala maintained an elaborate rock garden that was illuminated at night. Scala even had postcards printed in 1933 to promote this Warren Park attraction.

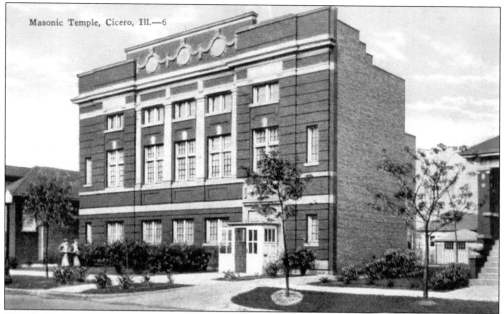

The lodge members of the Cicero Masonic Temple, 2525 Austin Boulevard, were called Freemasons. This fraternal organization had its roots in the guilds of stonemasons who built the castles and cathedrals of medieval Europe. The Mason lodge building, seen here in a 1920s postcard view, is now a church, the Roca Christian Center.

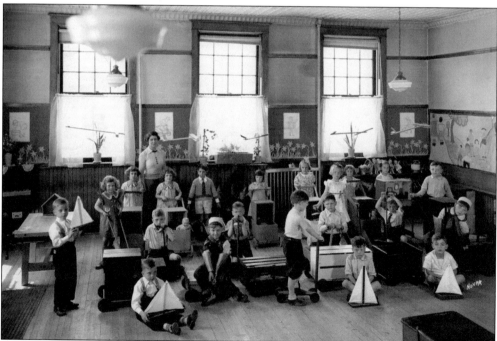

Phyllis Surdyk was the first-grade teacher at Woodbine School, Thirtieth Street and Fiftieth Court, when this photograph was taken in 1937. She eventually became the wife of Dr. Joseph Ondrus, a school superintendent. The couple, much beloved by Cicero students, attended every sports event and school activity in the community.

A series of postcard views in the 1930s featured the new houses of worship in Cicero. Warren Park Presbyterian Church (top), 6130 Twenty-first Street, was built in 1935. It was copied after a church in Tabor, Czechoslovakia, and had more members of Czech descent than any other protestant church in the suburban area. The Cicero Bible Church (bottom), a red brick structure built in 1929 at 2212 Laramie Avenue, was serviced for decades by itinerant preachers from the Moody Bible Institute until the building was finished.

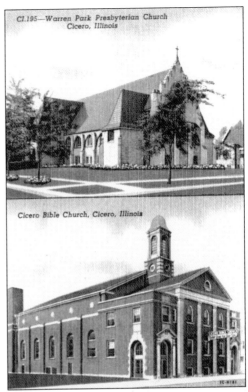

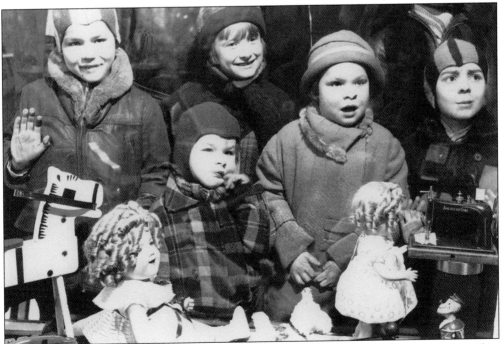

During this era, children loved dime stores, especially at holiday time. The crowded window displays of F. W. Woolworth's at 5206 Twenty-fifth Street in 1936 showcase media-influenced toys, such as a figure of Popeye the Sailor Man and Shirley Temple dolls.

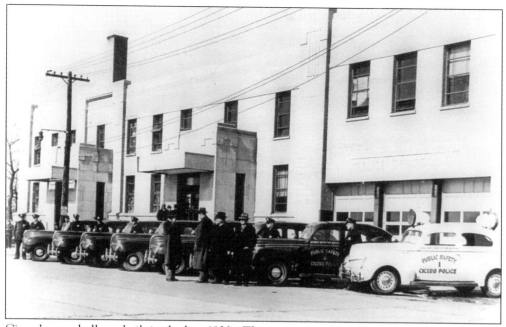

Cicero's town hall was built in the late 1930s. The project was financed under the WPA (Works Progress Administration) at a cost of $80,000. Plans began in 2006 for a replacement since the old structure is now outgrown and outdated.

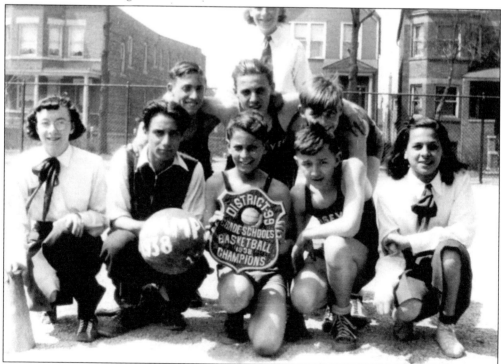

Some eighth graders from Theodore Roosevelt School, 1512 Fiftieth Avenue, pose on the playground with their basketball championship plaque in 1938. (See Mary Hapac, the cheerleader on the left, four years later, page 90.)

There were once a number of well-known Bohemian eateries, bakeries, and shops in Cicero. The Klas Restaurant, 5734 Cermak Road, is one of the few remaining. Klas has served authentic Czech cuisine since 1922. Owner Adolph Klas (seen in the oval) provided his customers with free postcards, an excellent way to advertise his business.

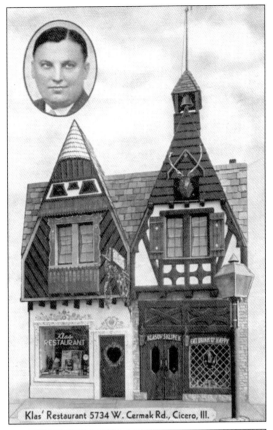

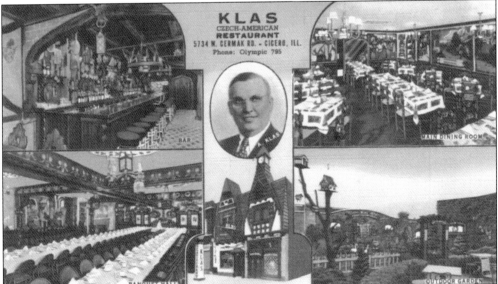

Over the years, one could watch Adolph Klas age on his postcards. He built tiny rooms for private use of gangsters and their girlfriends. During the years of the Capone occupation in Cicero, Al Capone often played gin rummy with his gang in the second-floor Moravia Room. A deck of playing cards the mobster kingpin actually used is on display in the lobby.

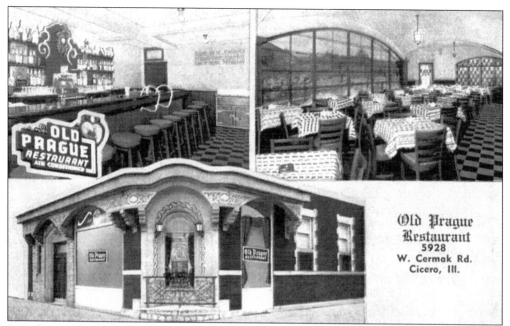

Long known for its strong ethnic roots, Cicero capitalized on its heritage by providing a number of popular Bohemian restaurants. Many out-of-towners enjoyed visiting Cicero for a gourmet night out. The meals were hearty but affordable at Old Prague, 5928 Cermak Road.

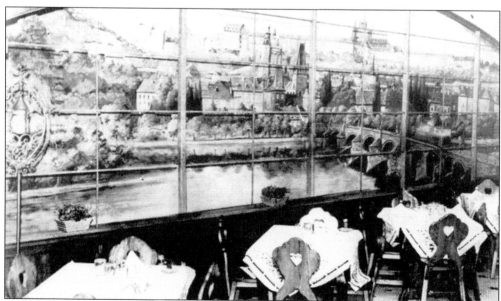

Old Prague was not to be outdone by Klas. They too gave their guests a variety of postcards over the years. On this one, postmarked June 8, 1939, Raymond raved to his cousin Fred about his dinner of "braised beef cutlets and sweet-sour cabbage." Old Prague burned in the 1990s. A Walgreen's drugstore now stands on the site.

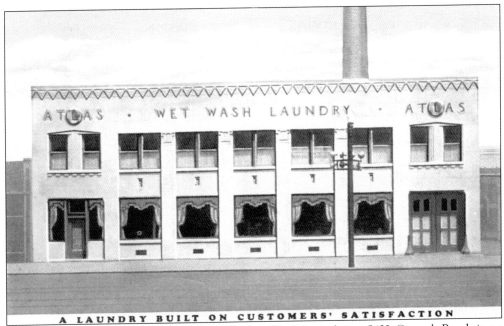

The art deco building from 1929, the Atlas Wet Wash Laundry at 5432 Cermak Road, is no longer standing. This site is now a vacant lot between two fast food restaurants. This style of architecture, which emphasized a streamlined, sleek, geometric look, is not well represented in Cicero because art deco grew popular just as America was entering the Great Depression.

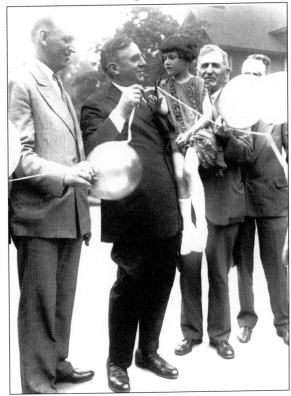

Cermak Road, formerly Twenty-second Street, was renamed in honor of slain, Czech-born Chicago mayor, Anton J. Cermak, who took an assassin's bullet intended for Pres. Franklin Delano Roosevelt in 1933. "Tough Tony," seen here with a little girl in his arms, had a special fondness for Cicero, appeared at Czech functions, and often danced with his wife at the Sokol Slavsky.

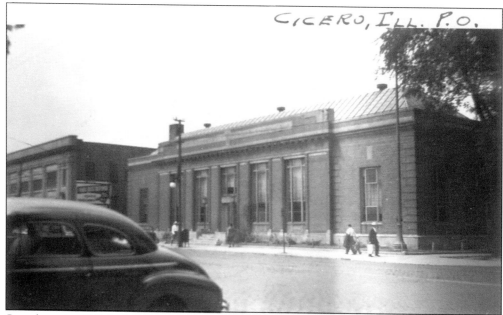

Seen here in 1941 is the Cicero post office, erected on the southwest corner of Fifty-second Street and Twenty-fourth Place in 1932 at a cost of $120,000.

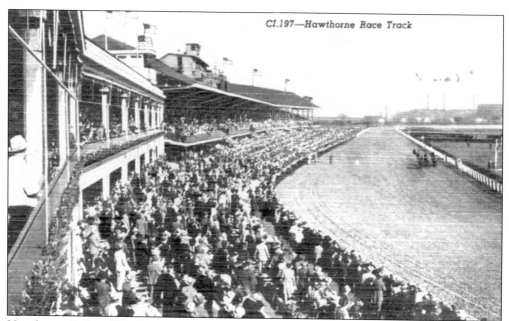

Hawthorne Park at 3501 Laramie Avenue became the first racecourse to install a public address system. The grandstand burned to the ground in 1978 but was subsequently rebuilt. For years, the el stop at Laramie Avenue brought the racetrack crowd to Cicero.

In 1941, Rosemary Pietrzak poses at 2113 Fiftieth Avenue in the Parkholme neighborhood. This district, formerly a wide pasture area, had been the Cicero Air Field from 1911 until the field was quickly outgrown. More spacious land was needed to accommodate longer runways for the increasingly larger planes. (Rosemary's father, Stephen Pietrzak, looks like a young Marlon Brando on page 48.)

Seen here in December 1941 is one of the branches of the Cicero Public Library. This one, intended for the children in the north end, was located in Roosevelt School, Fiftieth Avenue and Fifteenth Street. On December 7, Pearl Harbor was attacked by the Japanese. Boatswain's Mate Joseph P. Steffan (1911–1941), who lived at 1919 Sixtieth Court, was killed aboard the U.S.S. *Arizona* that day. Pearl Harbor plunged America into World War II.

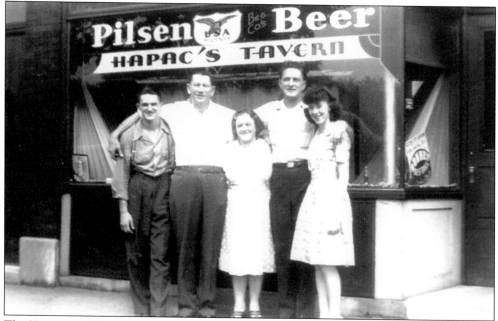

The Hapacs and three of their four children pose in front of their family tavern, 1533 Laramie Avenue, in 1942: (from left to right) Joe, father Martin, mother Eva, Martin Jr., and Mary. They lived upstairs. Mary is wearing a dress she made in her domestic science sewing class at Morton High School. Son Bill, a local baseball hero, was already in the service when this wartime photograph was taken. Hapac's Tavern had a ladies' entrance toward the rear of the building. Respectable women would never be seen entering a bar, but women schoolteachers often dropped by for a quick lunch.

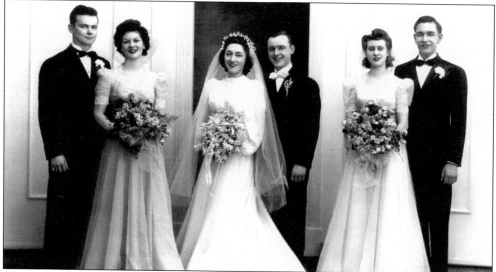

Josephine A. Spero married Marvin E. Hetzel on May 2, 1942, at St. Valentine's Church Rectory, 4948 Thirteenth Street. At their small reception at the Parkholme Community Center, 1820 Fifty-first Avenue, the wedding party realized they "only had about two bucks" among them, Marvin remembers. The bride and groom promptly opened their gift envelopes to pay for the festivities. Marvin went into the Marines soon afterward.

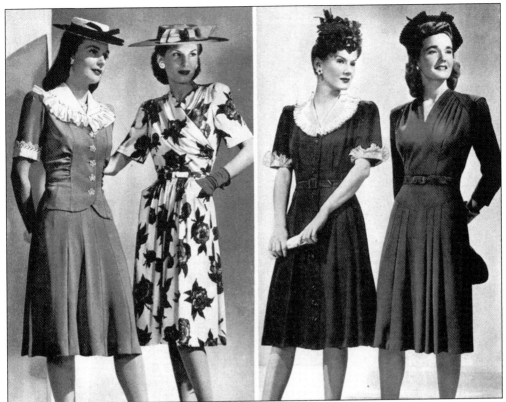

DeMar's Fashions, 6101-6105 Cermak Road, was a popular women's clothing store for decades. These rayon crepe outfits, typical of the broad-shouldered look of the wartime years, were selling for $5.90 in 1943. Today the site is a Blockbuster Video.

Cicero boys often ended up stationed together during World War II. Here are Larry Streck and Joe Hapac on Saipan. In June 1944, the U.S. Marines invaded and spent three weeks in hard fighting with the Japanese in order to secure the island. (See Joe on pages 72 and 90.)

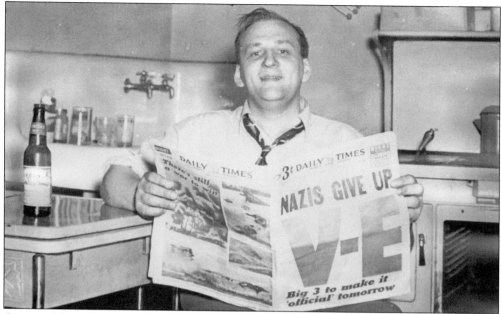

Cicero celebrated as Pres. Harry Truman went on the air on VE Day, May 8, 1945, to announce that Allied armies had been victorious in Europe. Here, enjoying a bottle of beer at the kitchen table in the apartment behind the family store, Martin Habada of 5817 Sixteenth Street is reading the good news in the progressive evening newspaper, the *Daily Times*. Three years later, that paper would merge with the *Chicago Sun* to become the *Sun-Times*. Habada became a popular television repairman in Cicero during the next decade.

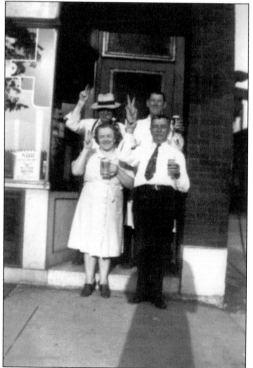

Later in the summer, on August 14, 1945, America joyfully celebrated VJ Day—Victory in Japan. The war was over! Martin and Eva Hapac's sons were overseas, but the joyful couple stepped outside their Laramie Avenue tavern with several customers to toast the victory. In the front (from left to right) are Eva Hapac and Mike Prelec; in the back are Jerry VanCura and Martin Hapac.

Four

THE CHALLENGE OF CHANGE

After the war, returning veterans faced the triple adjustment challenge of becoming reacquainted with their families, locating work, and finding their place in civilian life.

Although there had been virtually no new construction in Cicero during the 15-year period of the Great Depression and World War II, the previously undeveloped south sections of the community experienced a building boom in the 1950s. This area, formerly a series of connected vegetable farms, was developed as Boulevard Manor, which was named for Austin Boulevard.

During this era, things in Cicero were much calmer than the media and lingering legends might lead you to suspect. But in the postwar period, the old image of the lawless, "wild west" town that played by its own rules did not go away. If anything, it seemed to intensify.

Gambling and vice flourished during the 1950s and 1960s. Half-hearted periodic crackdowns were unsuccessful. But the average hard-working, law-abiding Ciceronian, of course, never saw the strippers or patronized B-girls at mob-run dives like the Frolics, the Turf Club, the Magic Lounge, or the 4811 Club on Cermak Road, nor did they do business at the "book joints" at Twenty-fifth Street and Laramie Avenue. Yet crime reporters relentlessly labeled Cicero the "Walled City of the Syndicate" and "the Sin Town of Babes, Booze, and Bookies."

In the 1950s, because Cicero had become so synonymous with racketeering and corruption, for a while town officials seriously considered changing the name of the municipality to Hawthorne to upgrade its image.

Yet Cicero's reputation would sink even lower during the Civil Rights period.

Ever wary of outsiders, Cicero was protective of what it had. Residents realized their neighborhoods were ripe for the type of block-by-block "white flight" (often orchestrated by unscrupulous realtors) occurring in nearby West Side sections of Chicago. The concept of a diverse or "mixed" community was inconceivable at this time. Racial tensions mounted as residents resisted African Americans moving into Cicero.

In 1951, when a black family attempted to move into a Nineteenth Street apartment, a three-day riot drew 5,000 angry protesters. In 1966, when Rev. Martin Luther King threatened to march through Cicero because of the town's history of intolerance, he was advised such an act would be a "suicide mission." During the 1960s, a period of conflict across the nation, Cicero was now perceived as anti-black as well as anti-law.

As the community celebrated its century anniversary, however, most Ciceronians remained focused on their families, enjoyed their lives and one another, worked hard, and lived comfortably.

There were several itinerant photographers in Cicero who snapped on-the-street shots of thousands of people over the years, especially families as they were leaving church. Nicely dressed and all together, they gladly purchased the postcard-size prints through the mail. In the Hawthorne neighborhood in 1950, Mildred and Edward Lipinski pause on the steps of St. Mary's of Czestochowa with their son, Eddie Joe. In 2006, Mildred continued her service as president of the Hawthorne Park district.

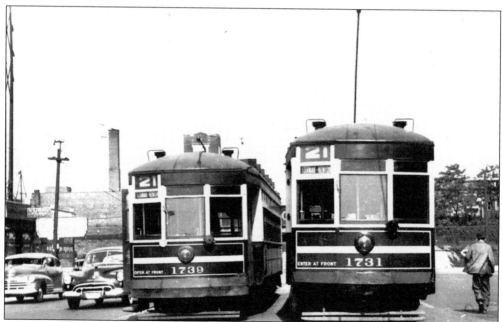

Streetcar lines made daily commuting into the Loop easy and affordable (nickel fares with free transfers). Seen here in 1951 near the end of the streetcar era, these two Cermak Road cars, which children often dubbed the "Toonerville Trolleys," are passing one another. The conductor rang the bell, made change on the rear platform, called out streets, and issued transfers.

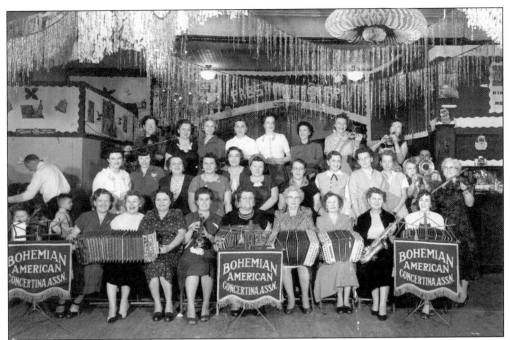

By the postwar 1950s, Cicero's population had become fairly Americanized, although ethnic clubs, parades, and holidays remained significant. These jolly ladies frequently gave concertina recitals.

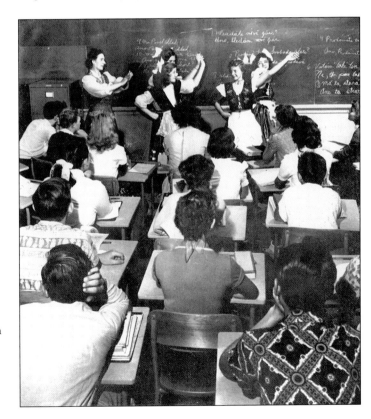

During the 1950s, Morton High School continued to offer Czech and Polish language classes, as well as several Bohemian folk dancing clubs.

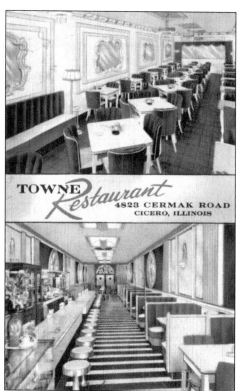

The Hawthorne Hotel at 4823 Cermak Road, Capone's old headquarters, eventually was renamed the Towne. After a 1970 kitchen grease fire, the building was razed. Today there is an empty lot on this site. Most of the old "Capone sites" are now gone.

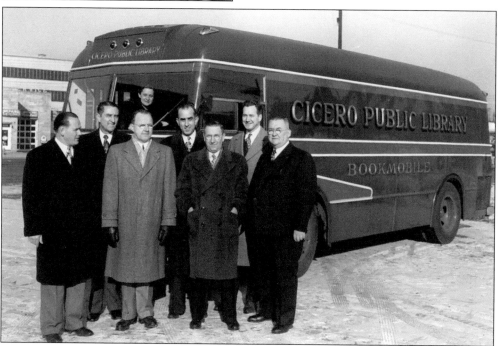

Beginning in the early 1950s, Cicero residents enjoyed a new trend in library service: a bookmobile brought "traveling" books to patrons in distant neighborhoods. A bus designed to carry 3,500 volumes made four-hour stops at 10 scheduled locations every two weeks.

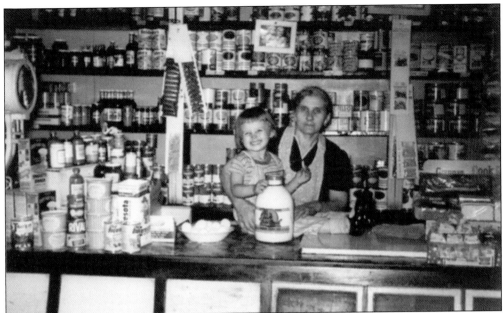

Small family-run grocery stores were located in most neighborhoods. Proprietors of these mom-and-pop stores knew customers' names and those of their children. By the 1950s, chain supermarkets offering self-service and lower prices drove many of these small stores out of business. Here Albina Habada poses with her granddaughter, Lois Sterba, around 1949, at 5817 Sixteenth Street. (Albina's son, Lois's father, is seen on page 92.)

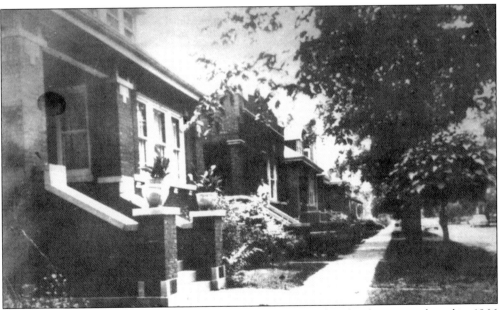

Five acres of residential property adjacent to Morton East High School were purchased in 1966 for the construction of a physical education and athletic complex. This quiet block, Fifty-ninth Avenue between Twenty-fourth and Twenty-fifth Street, was one that was bulldozed to make way for the new William J. Hapac Memorial Gymnasium, named for a beloved teacher, athlete, and coach. The outdoor facilities also included a baseball field and two practice football fields.

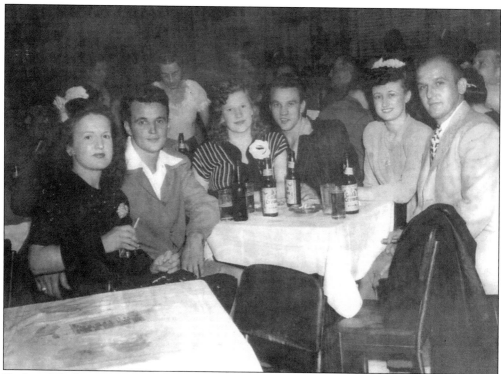

Emil and Dolly Strnad (center couple) met at a jitterbug dance in Londonderry, Northern Ireland, while Emil was serving in World War II. Emil was recuperating in Ireland after his participation in the D Day invasion on the beaches of Normandy. Emil married Dolly and then brought her back home to Cicero. Here the newlyweds enjoy an evening out with friends at a Cermak Road nightspot around 1947.

Many Cicero police officers of the late 1940s had seen military service. Their wartime training was a valuable asset to the department. Postwar electronics was also a boom to crime fighting. Radio sets were installed in patrol cars.

The sense of community intensified in the postwar period. Long-standing neighbors became like family. Here Edward Lipinski in the Hawthorne district poses with the neighborhood's Santa Claus, who was making the rounds on Christmas around 1950.

Sokol Slavsky continued to promote both physical fitness and mental health in the 1950s. "Sokol" is the Czech word for falcon, a bird known for its courage, endurance, speed, and sharp eyesight. It symbolized the ideas of the organization: fitness, strength, and high moral ideals.

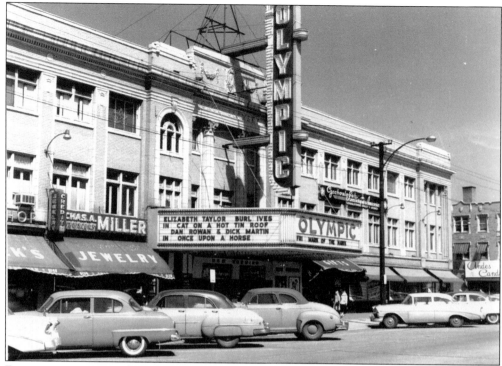

For many moviegoers, the Olympic Theater was a show in itself. Located in the center of the Sokol Slavsky building, the plush carpeting, upholstered seats, and stunning murals made the building elegant and exciting to its patrons. This photograph was taken in 1958 when *Cat on a Hot Tin Roof* with Liz Taylor was playing. Today the building is the Concordia, a combination banquet hall and a venue for live performances, just as in vaudeville days.

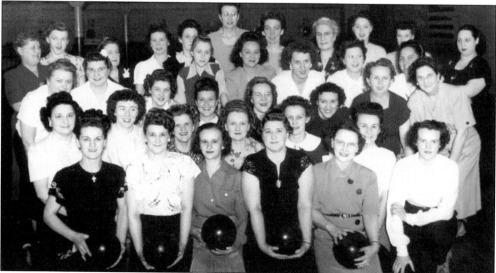

Many Ciceronians participated in bowling leagues in the postwar period. At the time, the pins were set by young boys. The use of automatic pin-spotters greatly speeded up the games and gave an even greater boost to the popularity of this enjoyable pastime in the 1960s. Seen here in 1948, the Crouse Bowling Alley was located at 5138 Cermak Road.

Before the age of fast foods, Cicero families seldom dined outside their homes unless it was a special event, like a wedding banquet or a funeral luncheon. In 1949, Fred and Martha Spirek are about to celebrate their 30th anniversary with their grandchild, Terry Spirek, and other family already inside the Klas Restaurant.

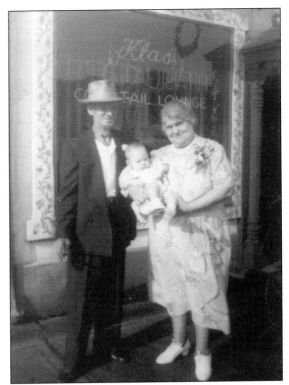

This 1960s calendar picture shows the Charles Fingerhut Bakery, 5537 Cermak Road, a favorite Cicero business where 600 pounds of Babi's rye bread was made daily. On Saturdays, they baked twice that amount. This is where the multicolor loaves known as Rainbow Bread were dreamed up and baked for decades. Fingerhut was also known for its butter coffee cakes, wedding cakes, and whipped cream cakes. Its slogan was "Once Tasted, Never Wasted." Today El Paraiso, a Latino pastry shop, occupies the site.

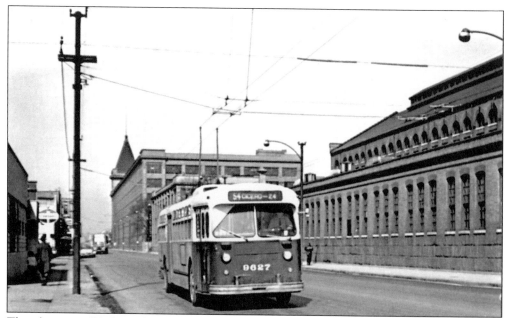

This electric trolley bus is heading south on Cicero Avenue in 1961. Note the massive Western Electric plant in the center background. During the period, Cicero was considered a "sundown town," which meant African Americans could shop or work there during the day but were unwelcome after nightfall.

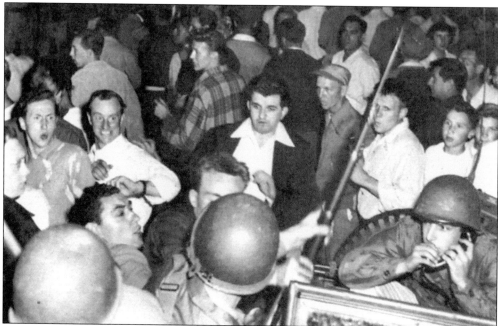

African American Harvey C. Clark Jr., a Chicago Transit Authority bus driver, World War II vet, and former aviation instructor at Tuskegee Institute, rented an apartment at 6139 Nineteenth Street for himself, his wife, and two children in July 1951. The Clark family was met by an angry mob that destroyed their apartment, trashed the building, and rioted for the next three days and nights.

Although the Clark family was able to escape unharmed, at its peak, the rioting involved as many as 5,000 people who fought police and deputies. As the mob hurled the Clarks' furniture (including their piano) from the broken windows onto the fire, an elderly woman told a reporter, "They're doing exactly right. They're only protecting our homes." Gov. Adlai Stevenson had to call out five companies of National Guardsmen. The 1951 "Cicero Race Riot" attracted worldwide condemnation.

The National Guard camped on the wide, open lot across from the "riot building" on Nineteenth Street. (The reason for the "double street" on either side of the apartment house is that in the late 19th century, the railroad came through that area.) At a subsequent court hearing, many people wore large medallions bearing the inscription "Keep Cicero White." No one was ever punished.

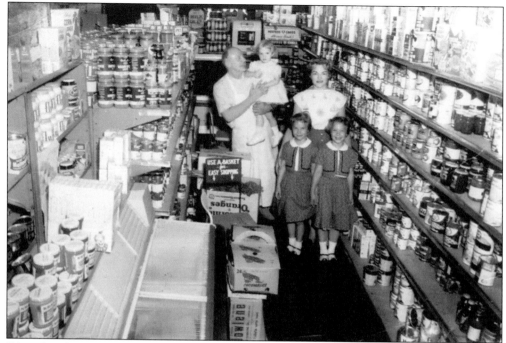

Edward and Josephine Gadzinski pose with their daughters in their family-run grocery store at 2903 Forty-ninth Avenue in the late 1950s. The building, a longtime mom-and-pop business in the Hawthorne district, burned down in 2006.

Parades along Cermak Road were an integral part of every Morton High School Homecoming weekend. Students enjoyed creating oversized floats for the procession, as can be seen here in 1955.

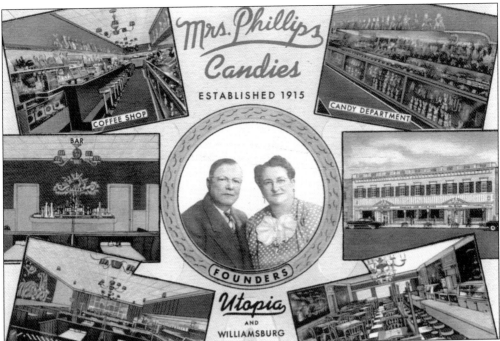

Mrs. Phillips' Candies, 4736 Cermak Road, opened as a small chocolate shop across from the Western Electric plant. But by the time this postcard was mailed in 1952, it had grown into one of the largest candy kitchens and restaurants in the region. A son who sent this free postcard to his father after a night on the town in Cicero wrote, "We sure are living tonight—cigars and all! Kathy was so full of pep she was dancing all over the place."

Someone once said that old-time Czechs focused their lives on the "Four Bs"—bungalows, banks, bakeries, and butcher shops. Cicero was always a sausage-loving town. Charles Shotola came from Bohemia in 1906. The Shotola and Sons meat market, 6137 Cermak Road, is seen on a 1960s advertising postcard. James Lelinek, in the bottom photograph, served 41 years as the store's sausage specialist.

During the 1950s and 1960s, numerous motels sprang up along Cicero Avenue that developed reputations as "hot pillow joints," especially when signs went up advertising day rates and hourly rates. The Turf Motel, 3126 Cicero Avenue, is seen on a 1971 postcard view with the twin spires of St. Mary's of Czestochowa looming in the distance. Today there is a gas station on this site.

Next to manufacturing, gambling became a major enterprise, whether it was horse racing or slot machines. They could be found everywhere. In one cursory sweep in 1967, 46 slot machines were found in Cicero. At that time, sexual commerce also prospered, although few vice arrests were ever made.

From 1895 to 1956, a ramshackle Laramie Avenue Bridge (also known as the Hump) that stretched across the CB&Q railroad tracks served as the most direct link between the residents of the Hawthorne and Morton Park districts. In its first life, this shaky structure spanned the Mississippi River at Burlington, Iowa, in the decades following the Civil War. The bridge had been purchased for $1 by Cicero officials, dismantled, and reconstructed on the Fifty-second Avenue site.

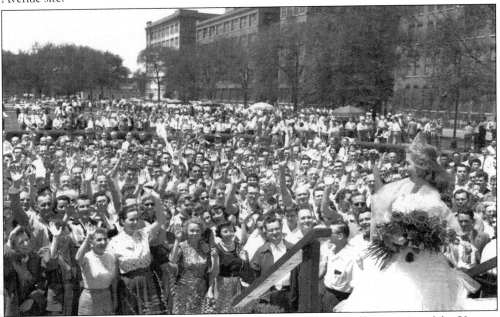

The annual Hello Charley beauty pageant at the Western Electric plant continued for 50 years (see page 80). During wartime in the 1940s, the contestants were called "V girls" to promote the war effort. This photograph shows the coronation of the Hello Charley queen and her court in 1957.

Contrary to what has often been reported, Martin Luther King never led a march into Cicero. In the 1960s, Cicero residents had reacted so violently to threats of integration that officials told King's supporters that marching there would be a "suicide mission." Although King did not participate, over 250 demonstrators—whites and blacks—marched through the town on Sunday, September 4, 1966. "Cicero sits on a time bomb, a powder keg ready to explode at a moment's notice," warned an editorial in the local press. "Stay in your homes. Keep off the streets. Keep your children indoors. Above all, keep your heads."

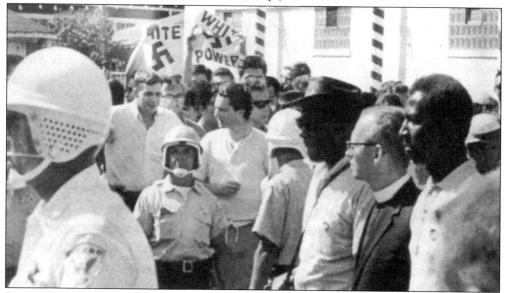

During a three-hour Sunday afternoon Civil Rights march, 3,000 police and National Guardsmen protected Cicero. Sidewalks were jammed to capacity by the jeering crowds. Although 38 hecklers (no marchers) were arrested for disorderly conduct and resisting arrest, the predicted "explosion of racial violence" never happened.

On January 26 and 27, 1967, 24 inches of snow fell with drifts up to six feet deep in many areas of Cicero. It was the most severe snowstorm of the century. College girls Colleen Harris (left) and Diane Buller appear happy that school has been cancelled. People trudged through the streets pulling sleds to do their grocery shopping.

The Bel-Air Drive-In, Thirty-first Street and Cicero Avenue, opened in 1949. It was not only one of the largest outdoor movie theaters in the region but was the last of Cicero's dozen theaters to close down in the 1990s. With its double-sided screen, it was possible to show two films simultaneously. At intermission time, while everyone headed for the concession stand, the reels were switched over to the other side. The Bel-Air was a magnet for teens on a night out with the family car. Although the name means "fresh air," the site was a former garbage dump.

During the 1960s, a group of outraged citizens, headed by a battalion of 11 Cicero protestant clergymen, led a movement to close down the vice and gambling dives thriving along the east end of Cermak Road. Many of these establishments were owned and operated by Cicero mobster Joey Aiuppa, who lived at 1836 Fifty-eighth Avenue. The crackdown was led by Rev. Joseph Holbrook, pastor of West Side Reformed Church, 1321 Austin Boulevard. For several years, although B-girls, strippers, and hookers were routinely seized, profiled, and prosecuted, the mob-run joints never closed up shop. This rather drab building is the infamous Frolics, 4813 Cermak Road, one of the most notorious of Cicero's nightspots. Originally owned by Al Capone, patrons enjoyed both the striptease floor shows as well as the basement gaming room.

While officials were touting Cicero's new title as the Best Lighted Town in America, federal agents were simultaneously dubbing it "the Walled City of the Syndicate." In 1963, Sheriff Richard Ogilvie busted over two dozen bookie and strip joints. After a second series of raids, he moved in a task force to patrol the streets, just as if Cicero had no police force of its own.

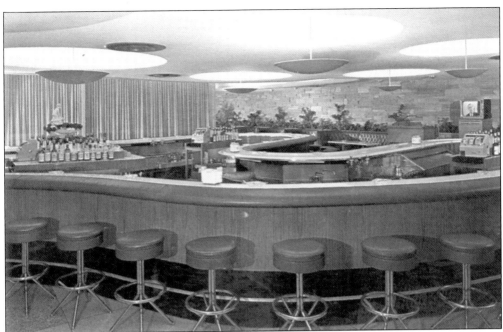

With 5,942 members, the Cicero Moose Lodge, 2348 Laramie Avenue, was the second largest lodge of the order in the world. Their purpose was fraternalism and charity work. They also enjoyed socializing. This is the Moose lodge lounge area around 1962.

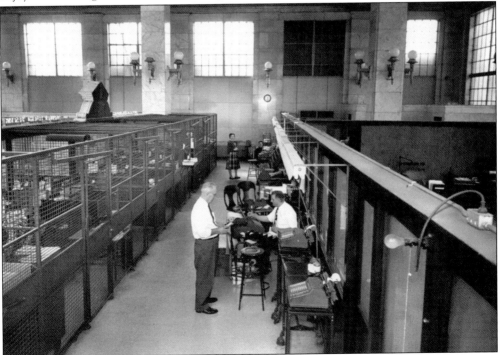

This 1960 photograph shows a behind-the-scenes view of the First National Bank, Cermak Road and Austin Boulevard. At the time, there were more savings and loan associations (22) on the strip known as "Bohemian Wall Street" than in any other area of the nation.

After World War II, mass production techniques that held down the cost of homes and sped up construction gave rise to a new south section of Cicero called Boulevard Manor. The subdivision, developed on former farmland, was named for Austin Boulevard, the main thoroughfare in the district. This brick two-story home, 3331 Sixty-first Court, is typical of the Georgian style that was popular with growing families during the baby boom era.

This 1955 Cicero automobile decal showed support for the Little League and Pony League. During the 1950s and 1960s, no suburban community was complete without a full schedule of Little League baseball.

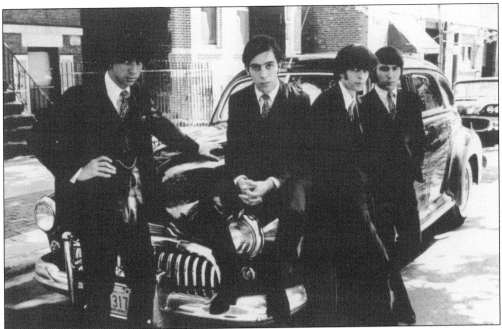

The Apocryphals, a Cicero rock band, had their photograph taken in their Grant Works neighborhood in 1967. From left to right are Joe Mantegna, Neal Sordelli, Tom Masari, and Chris Mantegna. Joe, who owned the 1947 Buick that the band toured in, was born in 1947. An Italian American actor who appeared in many Morton High shows, he made his professional debut in a stage production of *Hair* before winning a Tony for his work in David Mamet's *Glengarry Glen Ross*. He has appeared in many films, including *Godfather III* and *House of Games*.

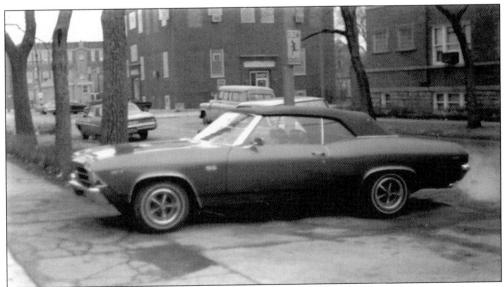

Ciceronians have long loved their automobiles. During the 1960s, there were at least 16 car dealerships in the community. This is George Cramer's pride and joy, his new 1969 Chevelle Super Sport. Cramer, a recently returned Viet Nam War veteran, always parked his under a streetlight for safety's sake, but the car was stolen a short time later.

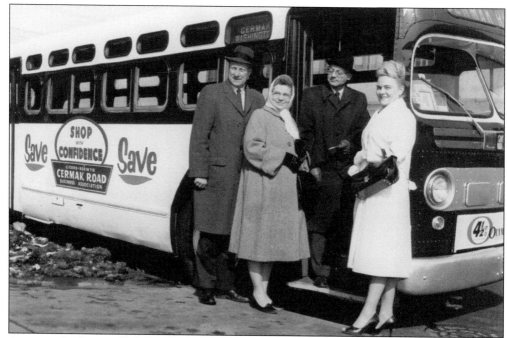

As new suburban malls began to boom in outlying areas, Cicero merchants began to feel the pinch. In 1962, this free shopper shuttle was provided so residents could more easily visit the stores along the Cermak strip. The lady in the white coat who came up with this plan, the energetic Lillian Baar, was the first woman president of the Cermak Road Business Association. Baar had opened her own real estate office in the early 1940s. She was also the mother of politician Judy Baar Topinka.

Although this snapshot of Olga Krecek with her granddaughter Terry Spencer was taken in the living room of her Warren Park home, many Cicero families often mocked their own tendency to live in the basement, doing everything from cooking to pinochle playing down there. The front room upstairs was a dust-free museum of unused brocade furniture protected by plastic slipcovers.

Five

FOCUS ON THE FUTURE

The late 20th century was often characterized by stress, disorientation, and a loss of vitality for Cicero.

Like so many old smokestack towns, Cicero lost jobs in the 1980s. The declining industrial base, especially the closing of the massive Western Electric plant, eliminated thousands of jobs. Danley Steel, Goss Manufacturing, Ceco Steel, and other factories also shut their doors or took their operations elsewhere.

The "graying" of the population resulted in smaller families and, for a while, declining census figures. Many aging fourth- and fifth-generation ethnics relocated into outlying western suburbs. There seemed to be fewer children around on the streets and in the schools. The population dipped to 61,232 in 1980. After a number of older businesses closed, once thriving commercial buildings began to fall into disrepair.

But also during the 1980s, there began a significant influx of young Hispanics who revitalized the community. In many ways, these newcomers, mostly of Mexican ancestry, mirrored the hard-working Eastern Europeans who had arrived earlier in the century. Moving out of their crowded city neighborhoods, they were seeking a better environment for their families and the chance to improve the quality of their lives. Many members of this new Latino population had roots in the Lower West Side or Pilsen neighborhood of Chicago, just like the Czechs and Poles who had migrated into the community long before them.

According to the 1980 census, Latinos had been only nine percent of the population. But by 2000, the number of Hispanics had swelled in Cicero to 77 percent. Within several decades, the town had changed from a white European enclave to one that was predominantly Latino. Yet during this transition, it became clear the newcomers exhibited the same civic pride, independence, and strong family values that had been the hallmark of Ciceronians for generations.

The Hispanic community has a high rate of entrepreneurship. New family-run businesses have revitalized the previously sagging Cermak Road commercial strip, as well as other Cicero shopping districts. These thriving establishments provide a solid income for their owners. The middle class continues to grow.

The revival of Cicero's commercial sector was witnessed on a number of fronts. A variety of mini malls were constructed as well as large retail "big box" stores like Sam's Club, Target, and Home Depot on the former site of the old Western Electric plant. Plans are being developed for an exciting future for Cicero, including a multiplex movie theater.

At the dawn of the 21st century, the town experienced a setback as government officials were convicted on charges of corruption, recalling Cicero's earlier reputation as a corruption capital.

Yet while nationally there was an increase in violent crime, Cicero saw a substantial drop in gang activity in 2005–2006, thanks to the skillful police work of the Gang Crimes Tactical Unit. New schools and innovative programs also continue to expand the horizons of the community.

There is a renewed sense of optimism in Cicero. The newer, younger generation has joined longtime residents in an exciting partnership, launching a creative adventure that seeks to energize all sectors of the population.

Cicero, with its roots deeply planted in the 19th century, continues to not simply survive but to grow and prosper with pride and self-confidence.

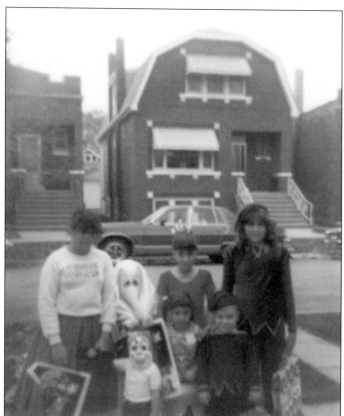

Cicero has always been a community that celebrates children. Here is a group of trick-or-treaters on Halloween 1981, pausing to collect their goodies at 1927 Fifty-ninth Court.

Because Cermak Road was in a slump in the 1980s, it received a much-needed face-lift that helped launch a new identity for the business district.

The factory that once provided many thousands of high-paying, secure jobs had become so outdated it closed down in 1983. Eighty-five years of Cicero history fell in less than 10 seconds with the demolition by implosion of the Western Electric tower on the corner of Cicero Avenue and Cermak Road (see page 58). For many, the razing of this historic structure symbolized a chilling loss of the long industrial supremacy of Cicero. Optimists said the cloud of dust signaled a new beginning for the town's economy.

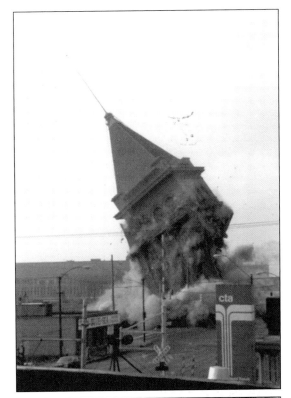

This mariachi band is playing in a Cicero banquet hall. As the Hispanic population increased dramatically during the 1990s, many new entrepreneurs revitalized the various business districts, opening everything from shoe stores to travel agencies. The increasing presence of Latino-owned businesses attests to their growing economic power. Mariachi bands are strolling Mexican musicians who play violins, guitars, trumpets, basses, and vihuelas, high-pitched five-string guitars.

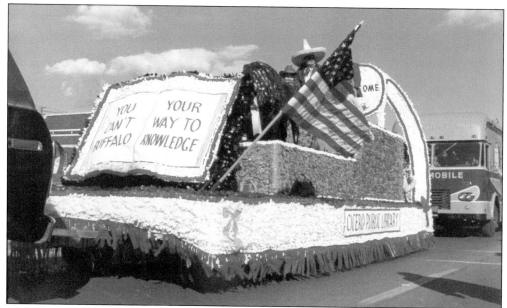

With the mushroom as its symbol, the Houby (pronounced ho-bee) Festival, sponsored by the Cermak Road Business Association, originally celebrated the Eastern European roots of the community. Highlights of the October festivities included the Houby Queen Pageant and the gigantic parade on Cermak Road. This is the library float from the 1980 Houby procession.

At the 1988 Houby Parade, Charlane Formella and her grandson Donny Kusper wave their flag in anticipation of presidential candidate George Bush and his wife, Barbara, who appeared on a float. Other Republican presidential candidates who have paraded in Cicero include Wendell Wilkie (1940), Dwight Eisenhower (1952), and Ronald Reagan (1980).

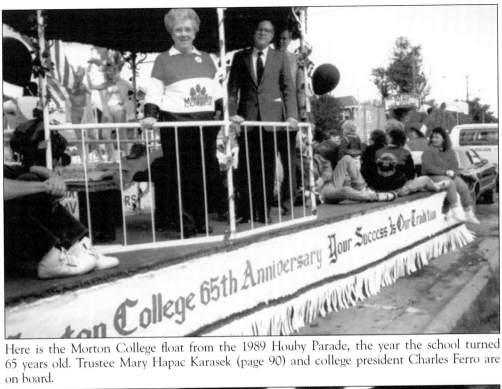

Here is the Morton College float from the 1989 Houby Parade, the year the school turned 65 years old. Trustee Mary Hapac Karasek (page 90) and college president Charles Ferro are on board.

Actress Ann Jillian (center) takes a break from filming her scene for a 1991 made-for-television movie being shot in Cicero Town Hall to chat with clerk Alice Darda and supervisor Russell Spirek. Spirek was a war hero in the South Pacific during World War II. Jillian and actor Robert Conrad starred in the pilot for a proposed series called *Marion and the Mob*. Conrad played a man seeking to adopt three children but was opposed due to his alleged syndicate connections. Other films using Cicero locations include the low-budget cult classic *The Psychotronic Man* (1979) and *The Blues Brothers* (1980).

Judy Baar Topinka, third from the left, a classic example of "local girl makes good," was the former Republican treasurer of Illinois who ran for governor in 2006. Here she typically joins in the fun of serving guests at an event held at the Wishing Well Banquet Hall, 5838 Twenty-sixth Street. Topinka often played her accordion at such festive occasions.

Ciceronians have always loved parades. This is the pom-pon squad, getting ready to march in the 2003 homecoming parade. The girls provided many outstanding half-time performances, too.

A musician named Veronica, in a photograph by Morton College photographer Esmeraldo Garcia, often played for masses at Our Lady of the Mount Church, now featuring services in Spanish, Czech, and English. The church is also called "La Inglesia de Nuestra Señora del Monte."

Betty Loren-Maltese has just won the position of town president. Helping her with the microphone is Ramiro Gonzalez, who would follow her in office to become the first Hispanic town president in Cicero.

Morton College, 3801 Central Avenue, had 5,244 undergraduates attending in 2006. Founded in 1924, the school is the second oldest community college in Illinois. This photograph shows the state-of-the-art Morton College Library.

Town president Larry Dominick (right, second row) sponsored a Cinco de Mayo President's Cup Soccer Tournament in 2006. The soccer match pitted the best young players from Cicero against the best from Chicago. The impressive trophy was affectionately named "Larry's Cup" by Cicero special events coordinator Frank Aguilar.

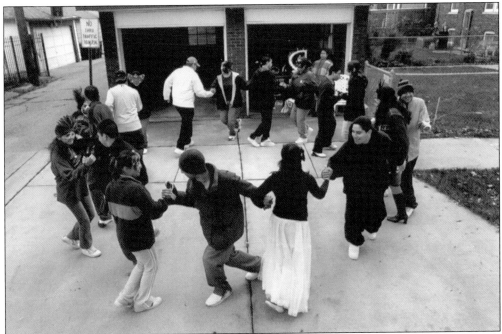

The most significant birthday for Mexican girls takes place at age 15. Their families put on a coming-of-age party called a "quinceanera." The preparations for both the parents and the debutante can rival many weddings. Here participants rehearse the dance steps in the alley of the 2000 block of Austin Boulevard.

Many Cicero businesses attract media attention, such as Freddy's Pizzeria, 1600 Sixty-first Avenue. With its corner store feel, Freddy's always has a line of people purchasing everything from gorgonzola-stuffed tortellini to house-made gelato and ices. An episode of the WTTW's program *Check, Please!* featured the popular Italian restaurant.

123

Betty Loren-Maltese, Cicero town president, poses at the opening of Safety Town, Thirty-fifth Street and Fifty-fifth Avenue. The child-sized village featured miniature replicas of buildings, railroad crossings, and other structures and equipment used to teach children safety awareness. In 2002, controversial Loren-Maltese was convicted on federal charges of misappropriating $12 million in town funds. While serving her prison sentence, she continued to enjoy wide support from many longtime Cicero residents who applauded programs she implemented, her community uplift, and her strong anti-gang stance.

After the abandoned Danley Steel building was demolished and the site was cleaned up to meet Illinois Environmental Protection Agency standards, a massive state-of-the-art school, Unity Junior High, was constructed. The new building at Twenty-first Street and Fifty-fourth Avenue, known as "Cicero's Crown Jewel," is one of the largest schools in the nation. Among Unity's many highlights are the two cafeterias designed to feed 4,000 seventh and eighth graders.

In 2006, Cicero town president Larry Dominick's literacy program enrolled over 120 students from kindergarten through third grade from both Liberty School and Cicero West School. Twelve eighth-grade students, such as the young man to the left, served as tutors for the program.

In 2001, Morton East High School's Dr. Hector Garcia (then assistant principal) is watching the homecoming parade with one of his daughters. Garcia, one of Morton's many success stories, knew little English when his family arrived in the Grant Works district in the late 1970s. He became principal of his alma mater, always promoting educational opportunities and nudging his student body to go ever further.

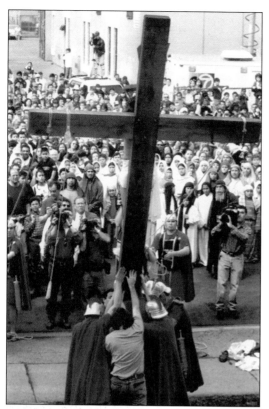

Mexican Catholics often identify more with the suffering Christ on Good Friday. That is when many families frequently gather together to share a meal, rather than on Easter Sunday. St. Anthony's Church in Grant Works has the largest Spanish-speaking congregation in the Chicago Archdiocese. Here is a glimpse of the Good Friday procession of 2006 in which hundreds of costumed parishioners participated to express their faith.

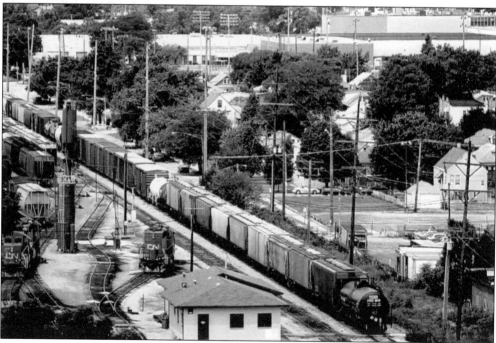

The Burlington Northern Santa Fe train-switching yard, south of Twenty-sixth Street and north of Ogden Avenue, still occupies a huge swath of Cicero.

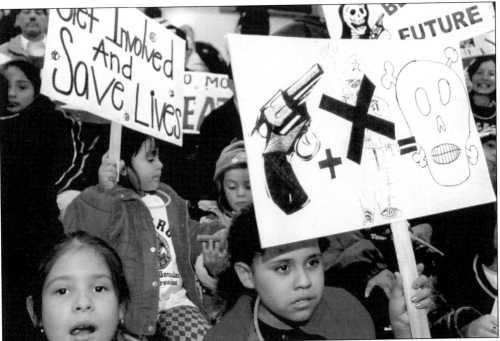

The Cicero Anti-Gang March is part of an ongoing larger effort by the Larry Dominick administration and the Cicero police to work together with young residents to combat the scourge of gangs and drugs within the community.

The Hawthorne Park District provides a full offering of outstanding programs for all ages. There are year-round activities, including lessons in crafts, arts, and sports. Here Dennis Raleigh, a lifetime Cicero resident and town trustee, is assisting in some children's games.

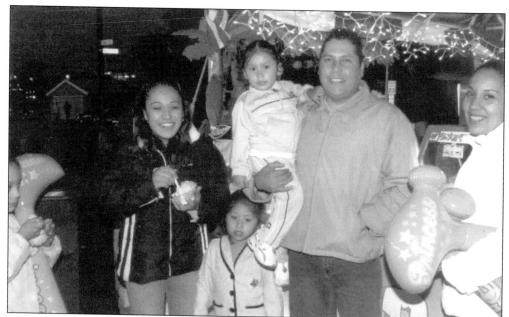

The many new families who have moved into Cicero continue to energize the town in exciting ways. These folks are visiting the Easter bunny in a special celebration held in April 2006.

This photograph by *Chicago Tribune* photographer Antonio Perez looks over east Cicero from the Laramie Avenue Bridge toward the Loop. The buildings of downtown Chicago can be seen in the distant haze. As the new Cicero moves forward with courage and inspiration, town president Larry Dominick says, "I am very optimistic about Cicero's future. There are a lot of good things on the horizon for our community if we stick together, work together, sacrifice together, and celebrate our successes together."